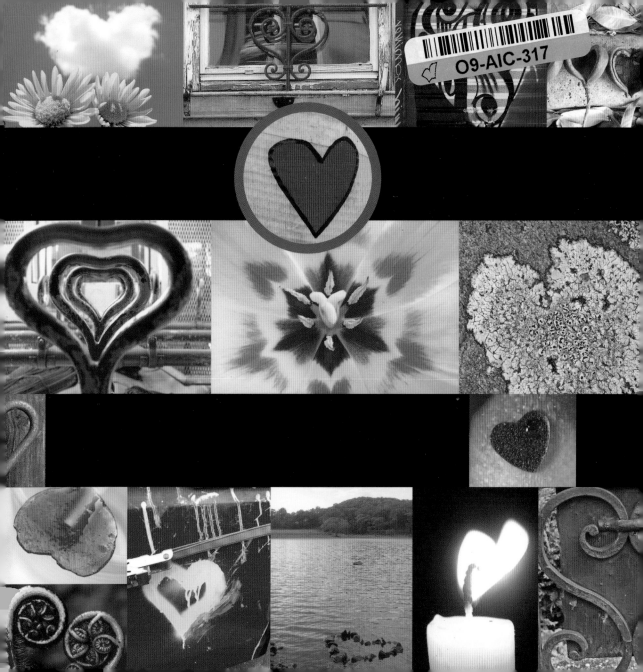

focus: love

Illustration: Michelle Testa '09

focus: love

Your World, Your Images

LARK BOOKS
A Division of Sterling Publishing Co., Inc.
New York / London

Senior Editor:
Nicole McConville

Image Editor:
Cassie Moore

Editor:
Julie Hale

Art Director &
Cover Designer:
Celia Naranjo

Page 7
Gabriele Helfert
Yellow

Library of Congress Cataloging-in-Publication Data

Focus, love : your world, your images. -- 1st ed.
 p. cm.
 Includes index.
 ISBN 978-1-60059-563-9 (hc-plc : alk. paper)
 1. Photography of handicraft. 2. Love in art. I. Lark Books.
 TR658.5.F63 2010
 779--dc22

 2009014892

10 9 8 7 6 5 4 3 2 1

First Edition

Published by Lark Books, A Division of Sterling Publishing Co., Inc.
387 Park Avenue South, New York, NY 10016

Text © 2010, Lark Books, a Division of Sterling Publishing Co., Inc.
Photography © 2010, Artist/Photographer

Distributed in Canada by Sterling Publishing,
c/o Canadian Manda Group, 165 Dufferin Street
Toronto, Ontario, Canada M6K 3H6

Distributed in the United Kingdom by GMC Distribution Services,
Castle Place, 166 High Street, Lewes, East Sussex, England BN7 1XU
Distributed in Australia by Capricorn Link (Australia) Pty Ltd.,
P.O. Box 704, Windsor, NSW 2756 Australia

If you have questions or comments about this book, please contact:
Lark Books
67 Broadway
Asheville, NC 28801
828-253-0467

Manufactured in China

ISBN 13: 978-1-60059-563-9

For information about custom editions, special sales, premium and corporate purchases, please contact Sterling Special Sales Department at 800-805-5489 or specialsales@sterlingpub.com

Contents

fo • cus: a central point of attraction

Your World

When walking down a busy city street or strolling through a wooded park, do you scan your surroundings with hungry eyes? Do you find yourself on a visual safari hunting snapshots of beauty, intrigue, or surprise amid the ordinary fodder of the everyday? All of us, from professionals to beginners, can take engaging and even breathtaking photographs just by observing the world around us. Meaningful images are everywhere, just waiting to be spotted and captured.

Your Images

Visit any number of online image-hosting sites, and you'll quickly realize how eager we are to snap, organize, and share what we see—in the form of millions upon millions of digital images. Technology has not only provided the tools, it has also fostered a vibrant community ready to embrace and encourage our infatuation with the visual image.

The Series

In *Focus: Love*, the first entry in a new series, this community's passion for the evocative heart shape takes center stage. Whether crafted by human hands, formed by nature, or simply extracted from the wealth of visual stimulation around us—graffiti scrawled on an alley wall, the sloping curves of an iron gate, shapes cut from paper by a child, worn stones scattered on a forest floor—hearts can be found almost everywhere…if you're looking.

The Focus

For many centuries and across cultures, the heart icon has been a symbol of union, togetherness, passion, love, spirituality, and even the essence of the human soul. It can evoke a sense of unabashed passion, a warm feeling of connection, or childlike wonder and joy. Maybe it suggests a longing for love lost or acknowledges life's emotional complexities.

Within these pages you'll find the work of 150 photographers from 35 different countries, along with some of their reflections on the heart as a symbol and on the theme of love in general. Their images range from sweet to sublime, humorous to provocative—just like matters of the heart.

Peruse, and discover the magic before your eyes.

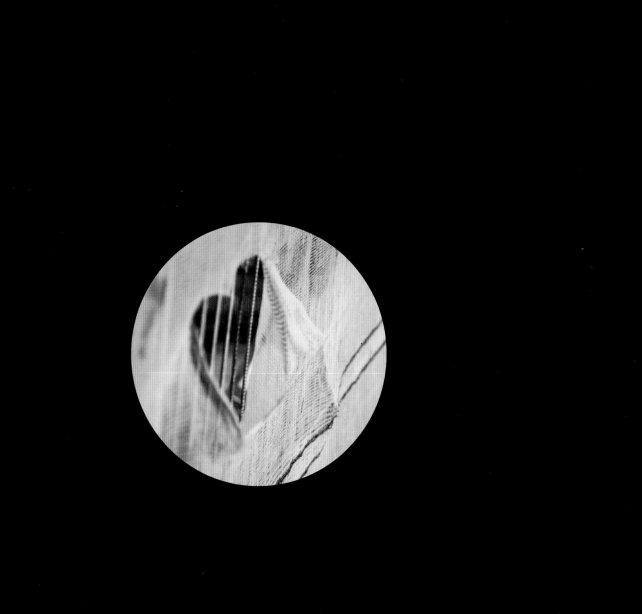

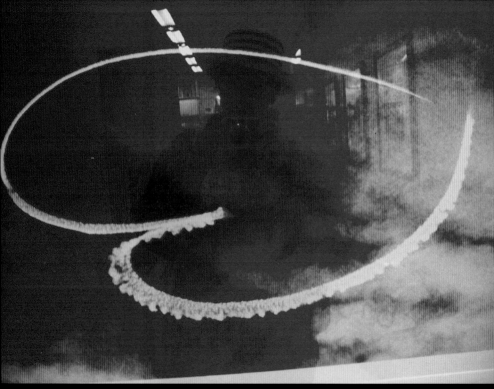

Marjorie Frost Fitterer
My Reflection in a Huge Glass Heart

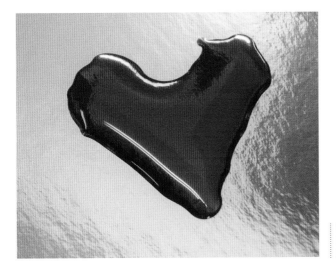

Kerstin A. Pesch
The Heart Has Its Reasons Which Reason Knows Not Of (Blaise Pascal)

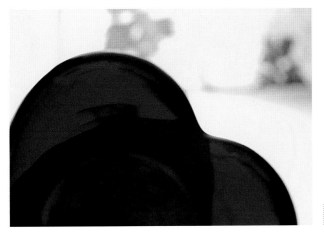

Helen C. Powell
A Piece of My Heart

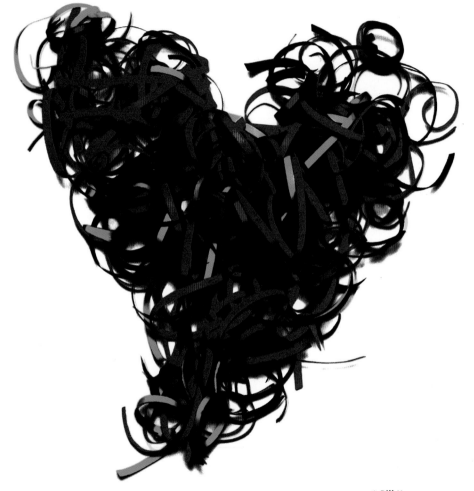

Bill Horne
Black Heart

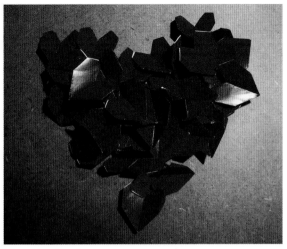

Jean Marc Zerafa
Cluster of Love

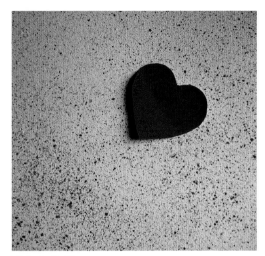

Priscila D. Alves
Colorful Love

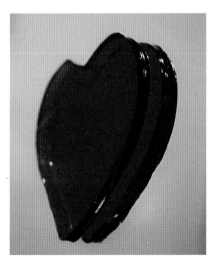

Livia Valeska
It's My Heartbeat, It's Getting Much Louder

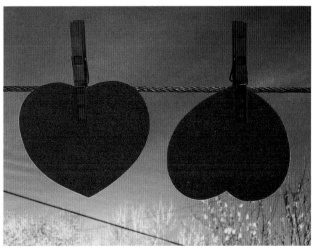

Rosana Claudia Marchini
*Estamos Atados en el Mismo Viento
(We Are Tied up in the Same Wind)*

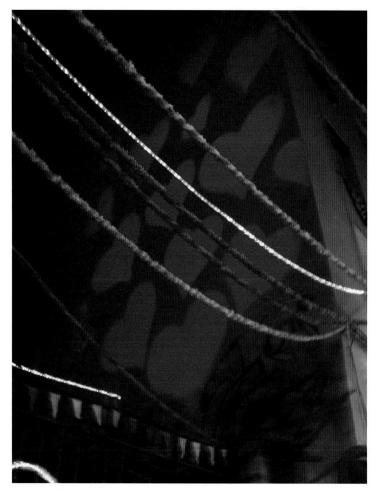

Carmen Maza
Fiesta de Corazones

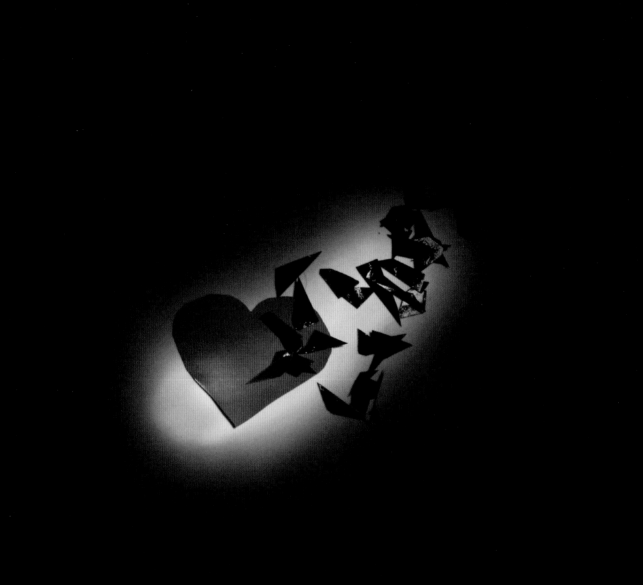

Raditya Fadilla
What Is Love?

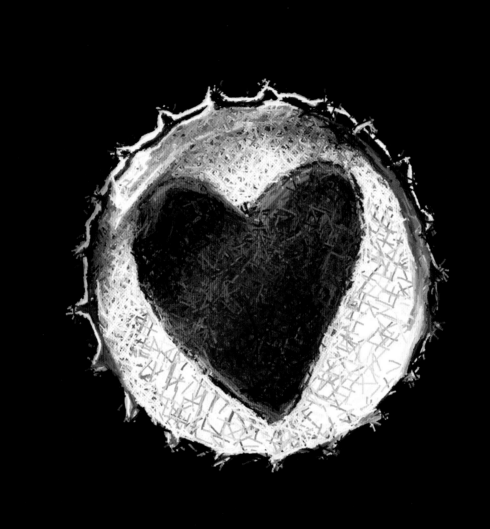

Ali Johnson
Of the Heart

Nancy Scott Dougherty
Heart Breaks in 2

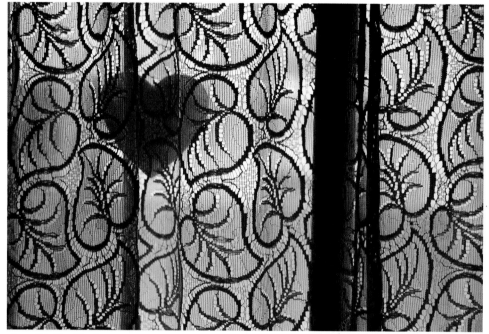

Joan Teixidor March
El Cor del Nus

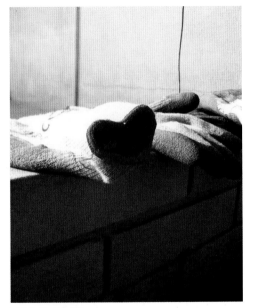

Maja Draginčić
Heart of a Glove

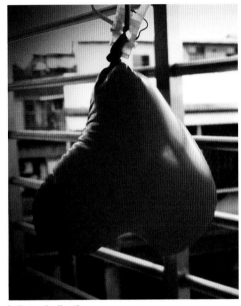

Christabelle Chen
A Withered Heart

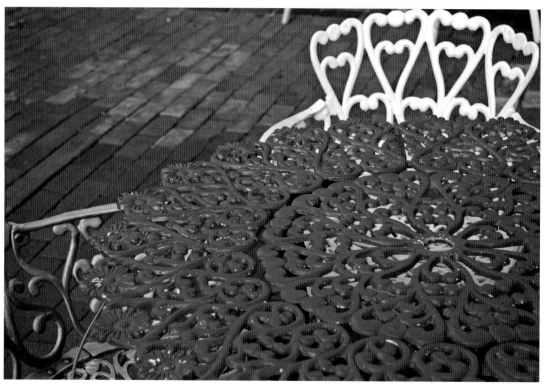

Jessica Starr Mundt
Old Town Love

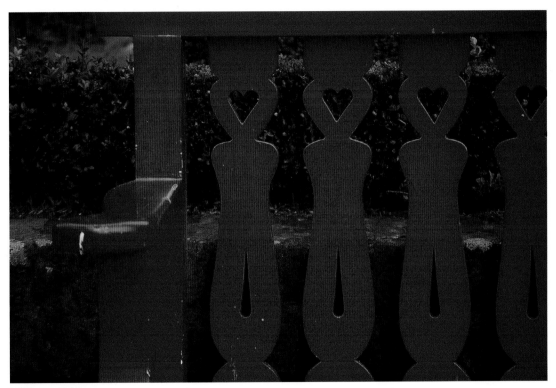

Milly van Helden
Red

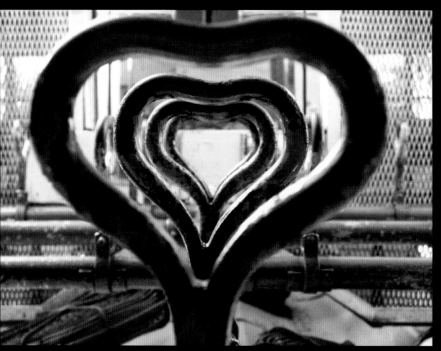

Mohit Korde
Fuzzy Hearts
This image was taken on a local train on the way to an early-morning photo shoot at the Dadar flower market in Mumbai, India. The local trains in Mumbai ferry close to seven million people each day from the suburbs to the business districts of the city and back. The daily commutes often leave ample time for life's interesting tales to unfold. Regulars get to know each other, and love often blossoms along the way. It can start with a furtive glance, a smile, or a shared story.

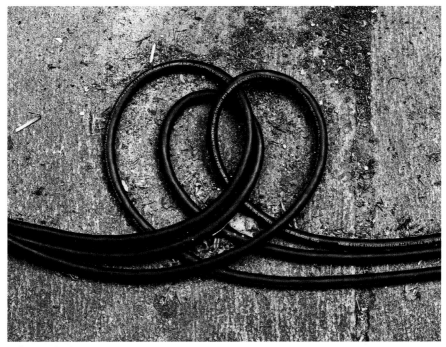

Alice Grebanier
Hearts

Debra Mineely
Rusted and Wired, Trusted and Tired

Darwin E. Bell
Turn the Heart to Open

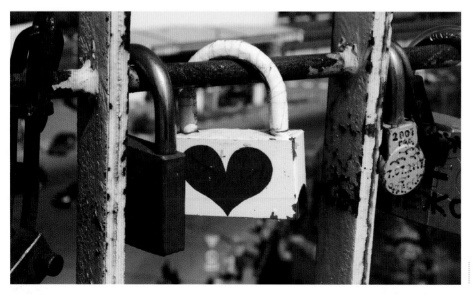

Anja Rehatschek
Locked Heart

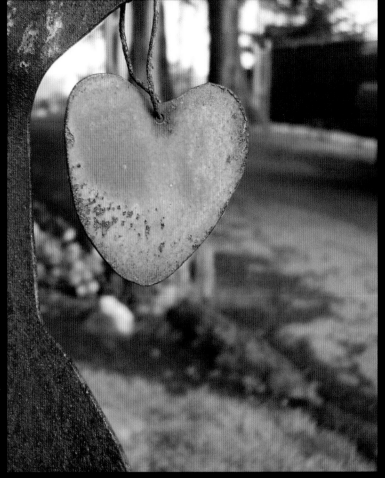

Darwin E. Bell
For Someone Special
This image was taken in Alamo Square in San Francisco, California. I was
in the rush of new love at the time, and the heart really stood out for me.
I love how it's slightly rusty.

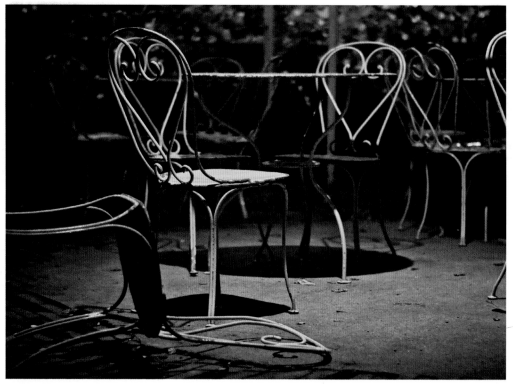

Mette Kramer Jacobsen
Heart Chairs

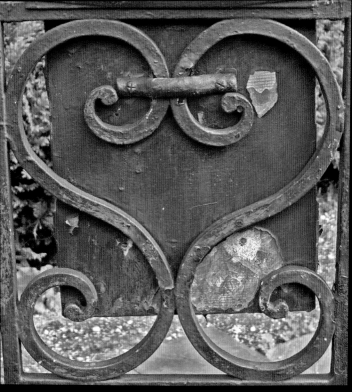

Catherine Bassal Salliard
Iron Heart

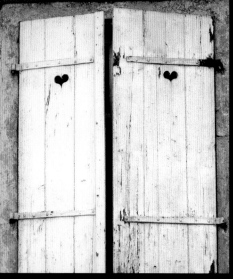

Catherine Bassal Salliard
The Heart-Shaped Eyes of the Shutters

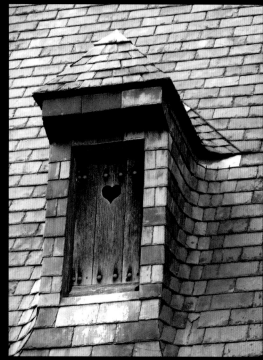

Catherine Bassal Salliard
A Heart on the Roof

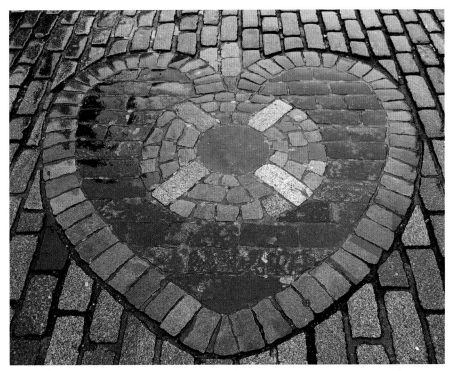

Lewis Outing
Heart of Midlothian
The cobblestones that form this heart are set into a foot-path outside St. Giles' Cathedral in Edinburgh, Scotland.

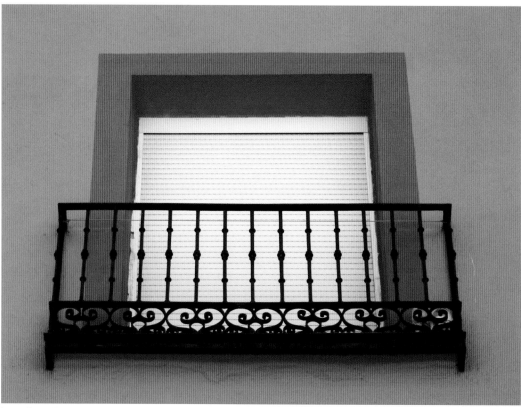

Sergio Zurinaga Fernández-Toribio
Un Balcón Lleno de Amor (A Balcony Full of Love)

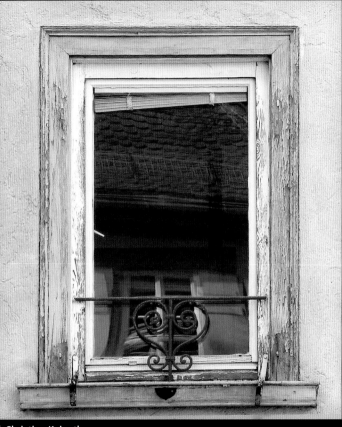

Christine Keinath
Window at Schwäbisch Hall

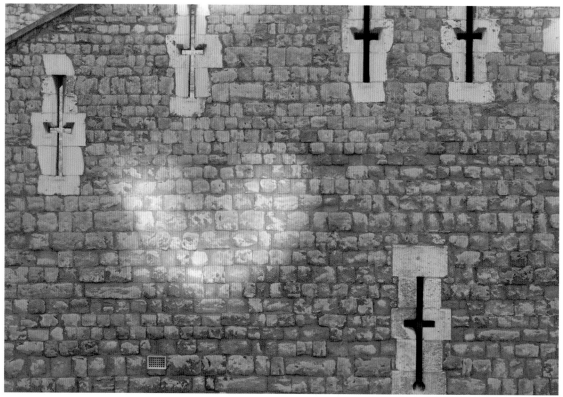

Willie Stark
Hearts & Castles

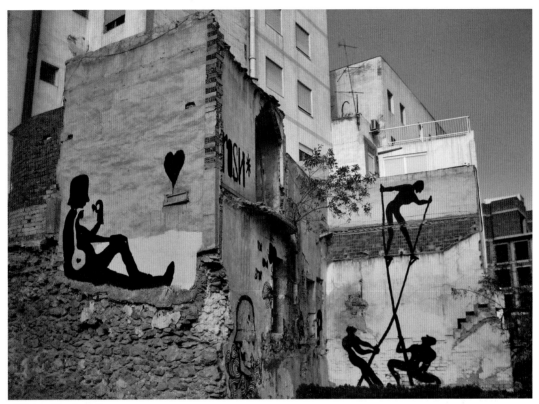

Máximo Ros González
Dimensions
This was a totally unexpected found image. A friend and I were walking downtown when we decided to wander around some blocks of flats. Suddenly, we came upon these marvelous wall paintings. I love the way the huge images are hiding from everybody—even from the people living in those flats.

Lester E. Weiss
San Francisco Heart

Lester E. Weiss
Untitled, San Francisco

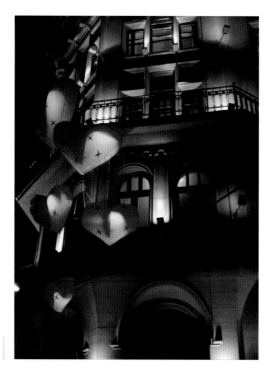

Gizem Inan Erman
The Witch Turned Me into a Building. Kiss Me?

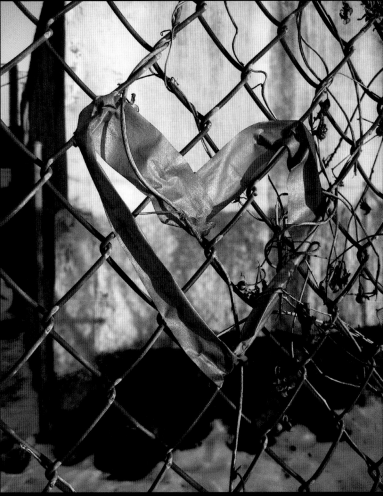

Julie Staub
Taped-Up Heart

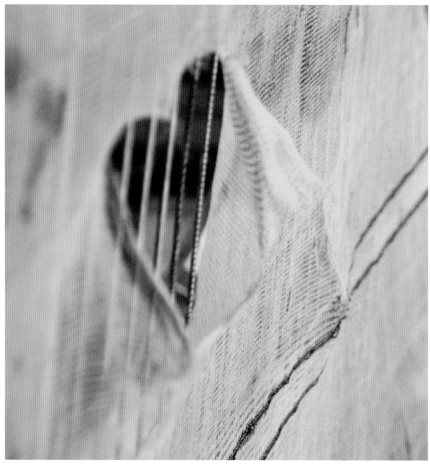

Gabriele Helfert
Yellow

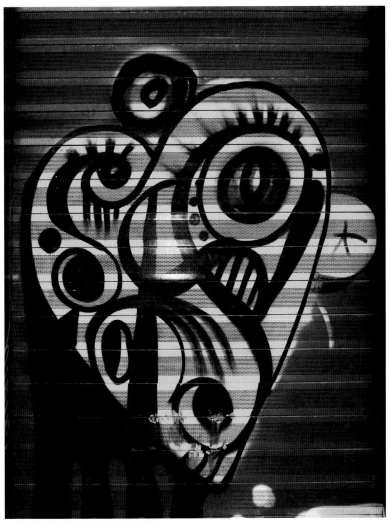

Sergio Zurinaga Fernández-Toribio
Street Heart

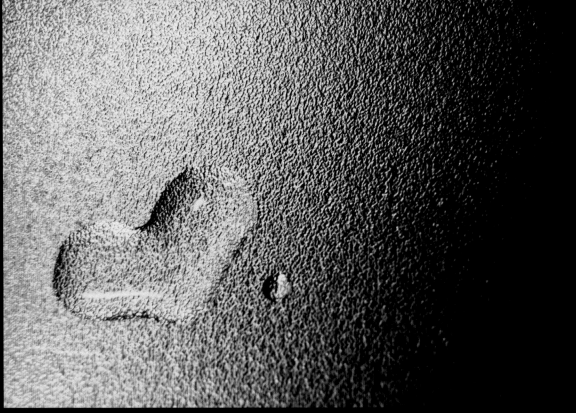

Madoka Komano
Love Is in the Air

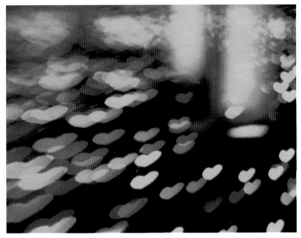

Mayumi Suzuki
Shooting Hearts

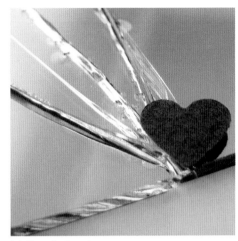

Juliette LeGrand
NY Valentine

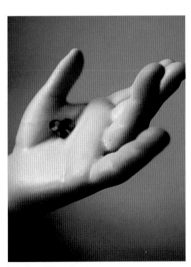

Debra Mineely
What Can I Give You

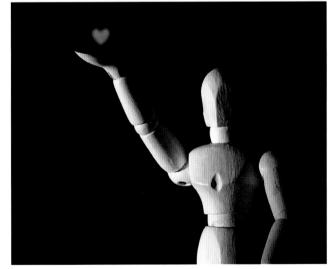

Simon Chung
On a Platter, My Love, If You'd Only Ask

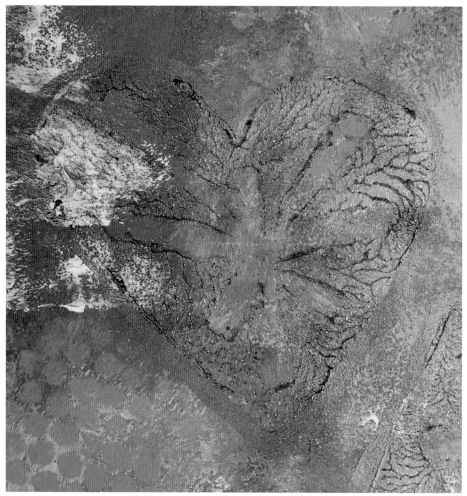

Judy Merrill-Smith
Wrapping Paper (Close Up)

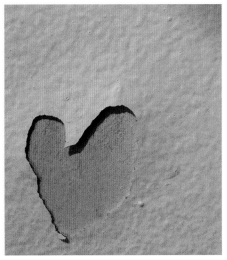

Darwin E. Bell
Painted Heart

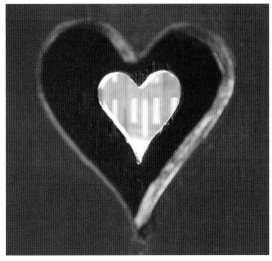

Mads Gildberg
Heart to Heart

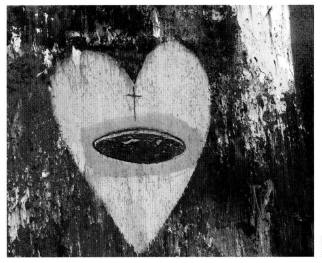

Julie Akers
Rusty Heart

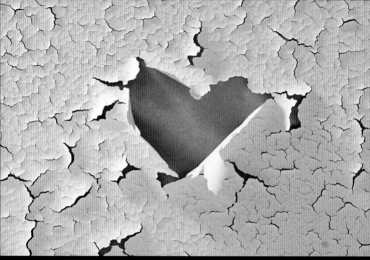

Erica Marshall
Heartbreak

Jessica Starr Mundt
Lumpy Love
I spray-painted this heart-shaped graffiti on the cars at the famous Cadillac Ranch in Amarillo, Texas. I love the lumpy texture that has resulted from the thick build-up of paint over the years.

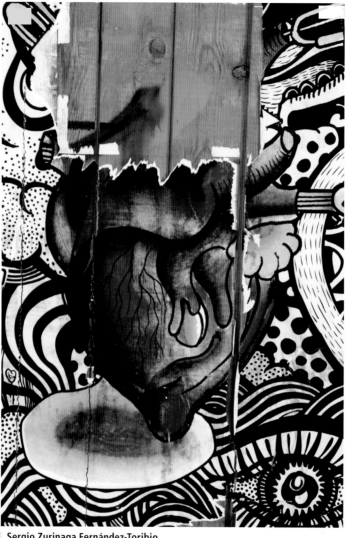

Sergio Zurinaga Fernández-Toribio
Un Corazón Sano y Otro Podrido (A Healthy Heart and a Rotten One)

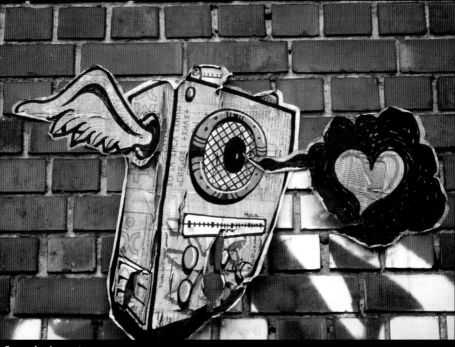

Françoise Lecomte
Street Art, Brussels, Belgium

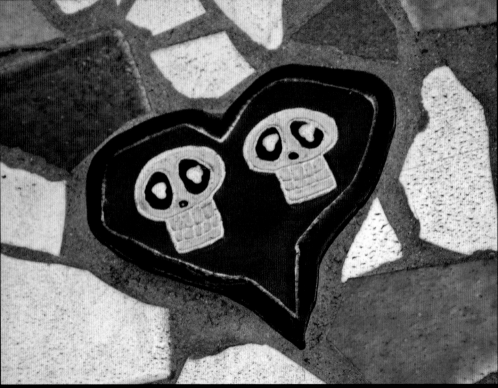

Jessica Starr Mundt
Handmade Skullies

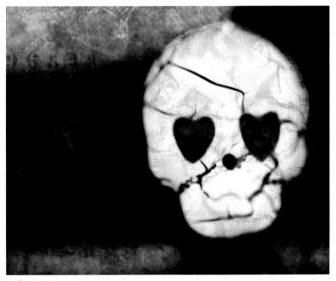

Ellen M. Yeast
Happy Skullentine's Day

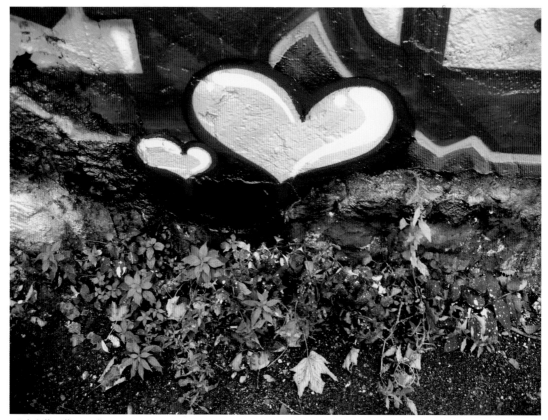

Gabrielle Allemand
Sacred Pink Hearts
The streets of Paris are filled with love!

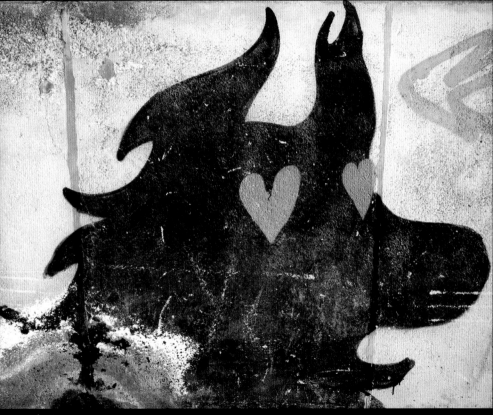

Françoise Lecomte
Street Art, Schuman Station, Brussels, Belgium

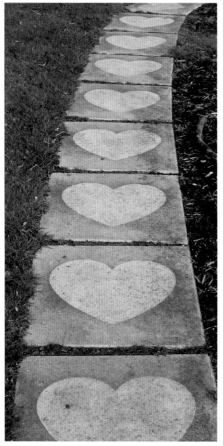

Sara Zamberlan
Can You Turn off the Love?

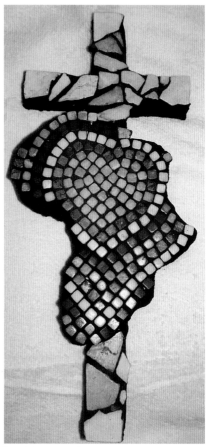

Kathleen L. Luther
A Heart for Africa Cross Mosaic
I made this mosaic out of limestone from Israel.
It was a 70th-birthday gift for a missionary friend
who works at two orphanages in Africa. She truly
has a heart for Africa.

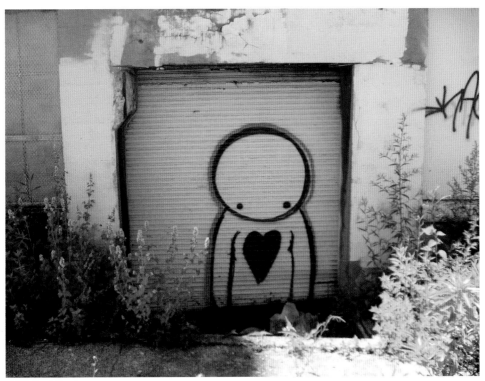

David Uhrin, Jr.
Have a Heart
I found this image while exploring my hometown of Cleveland, Ohio. I'm drawn to worn, torn, tired places that hold lots of stories and emotion. I found this heart in an industrial area, down an old road. When I saw it, I experienced one of those "I MUST capture this" moments.

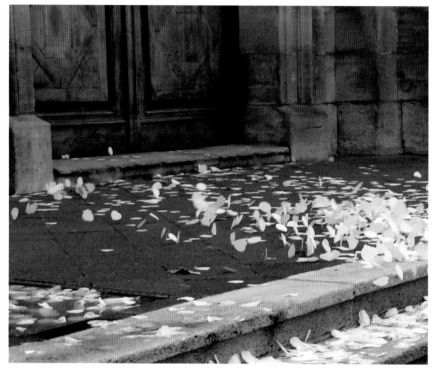

Catherine Bassal Salliard
Wedding-Paper Hearts in the Wind

Mylène Taillon-Viger
An Accidental Love Pattern

Eduardo da Costa
Mon Coeur S'Envole
I found this winged heart in the famous La Boqueria market in Barcelona, Spain. I love to spend time there when I visit. It's so colorful and lively!

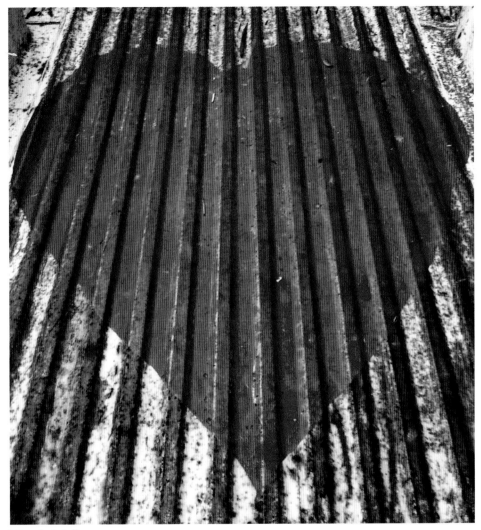

Darwin E. Bell
Heart in a Pickup Truck
I always look in the backs of pickup trucks, because you never know if there might be something in there worth photographing. In this case, there really was!

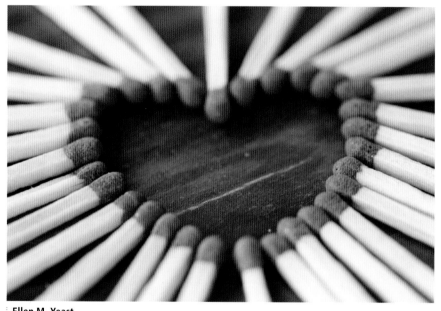

Ellen M. Yeast
Burn for You

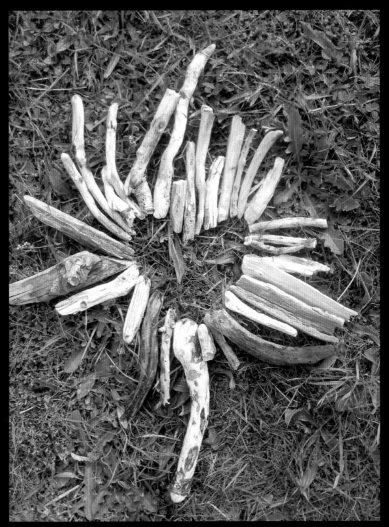

Mairi C. Stephen
Heart of Sticks on Grass

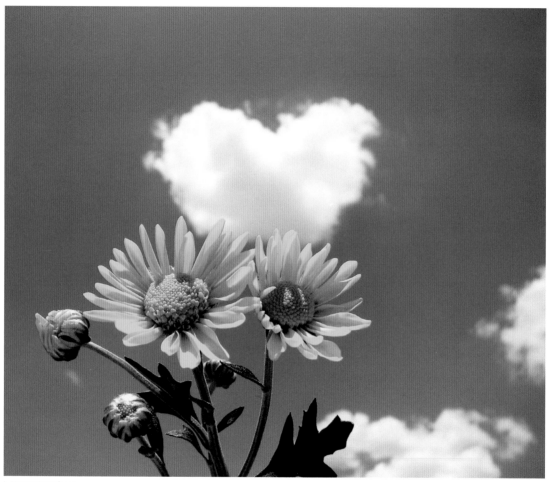

Horst Bernhart
Flowers with Heart…

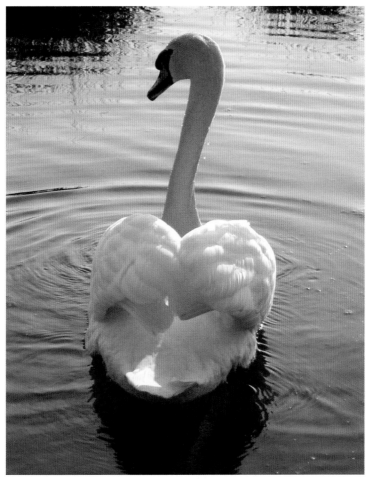

Charlie May
Heart Wings

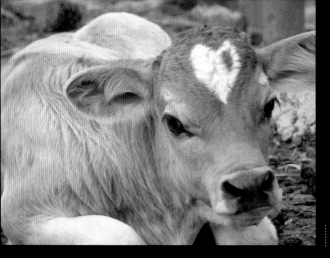

Otávio de Oliveira Franco Queiroga
Lover by Birth

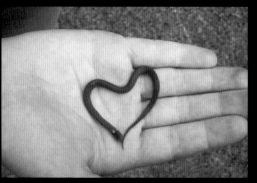

Kerstin A. Pesch
Look What I Found

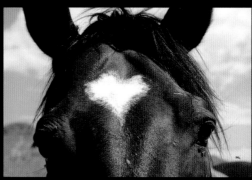

Willie Stark
Horse Named Heart, Really

Heather Pinkston
Love

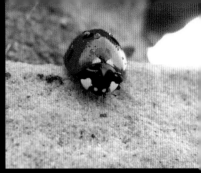

Manny Fernandez
What I Got

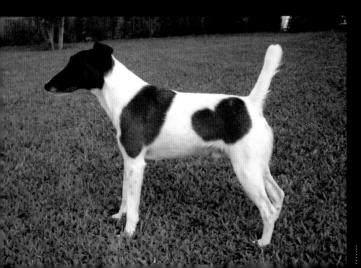

Edilson Rodrigues da Silva
Ernesto's Heart

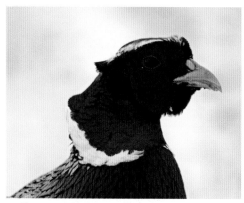

Jeffrey M. Gardner
Pheasant Love

Sarah H. Biggart
This Nose Knows Love
Hearts are one of my favorite things to spot and shoot.
They can be found hiding among us and occurring in
nature—almost like a little wink from the universe.

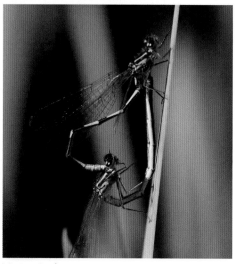

Petter Jordan
Love Is in the Small Things
During a field excursion in biology in western Norway, I
noticed these damselflies. They form a heart while mat-
ing. I chased the insects for a long time before I man-
aged to capture the moment of the heart forever.

Horst Bernhart
Bug with a Heart

Catherine Bassal Salliard
The Heart on the Beak

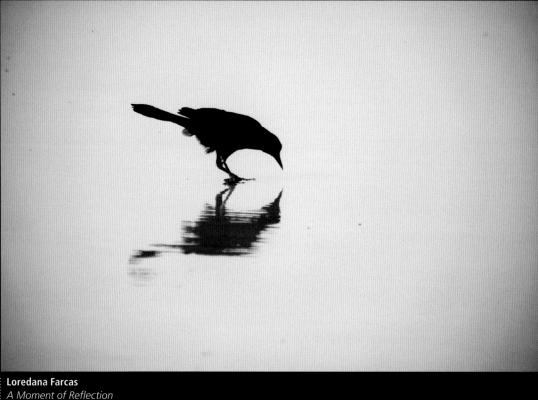

Loredana Farcas
A Moment of Reflection

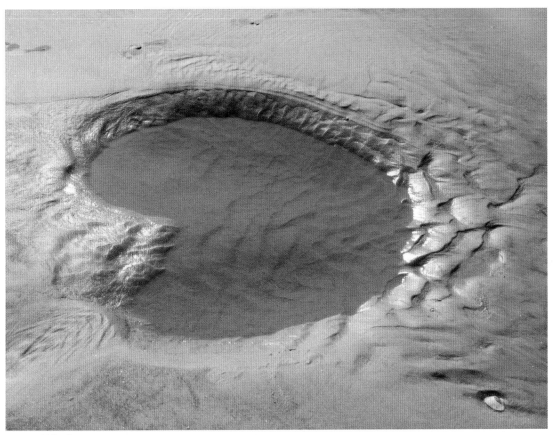

Peggy Reimchen
A Watery Heart

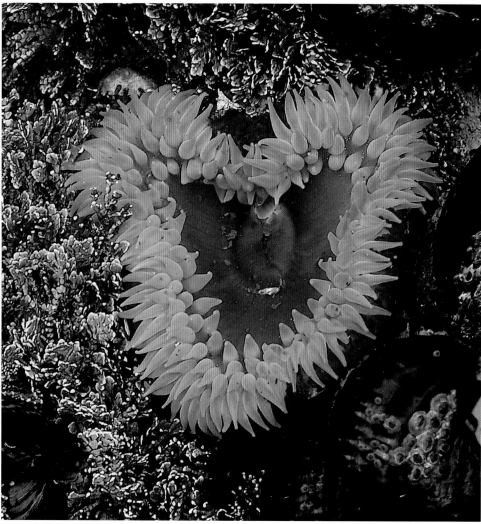

Flow Well
Heart Anemone

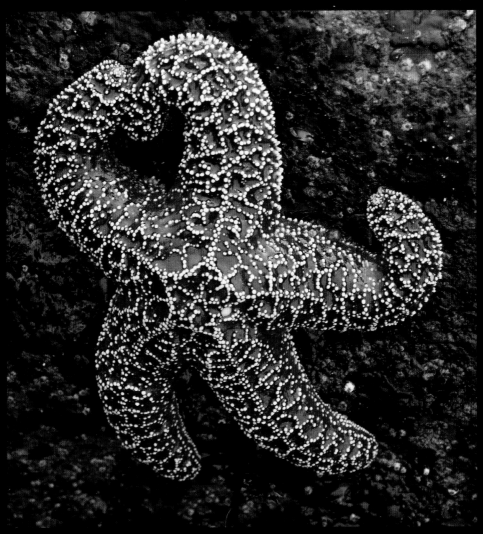

Flow Well
Looks Like a Heart to Me

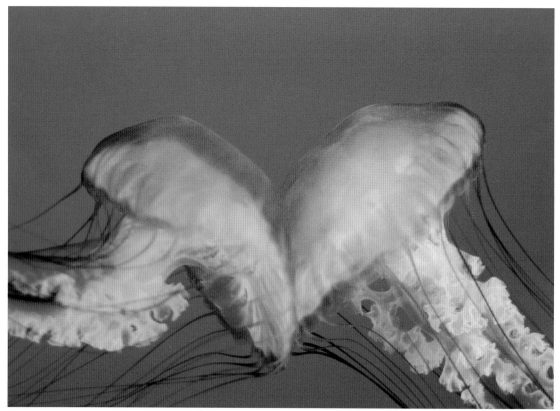

Jackson W.F. Chu
Sea of Love
I took this picture at a jellyfish exhibit that was held at the Vancouver Aquarium.

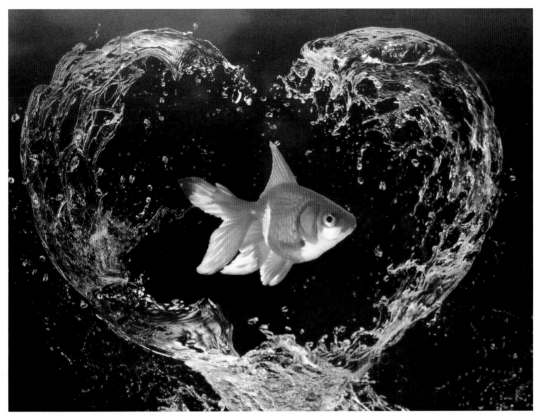

Sergio Zurinaga Fernández-Toribio
Corazón de Pez (Fish Heart)

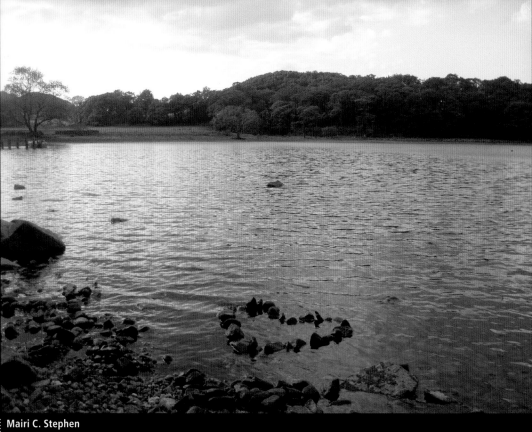

Mairi C. Stephen
One of My Favorite Spots

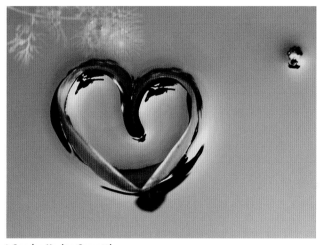

Sandra Karina Serretti
Secret Paradise—Dedicated to Zé

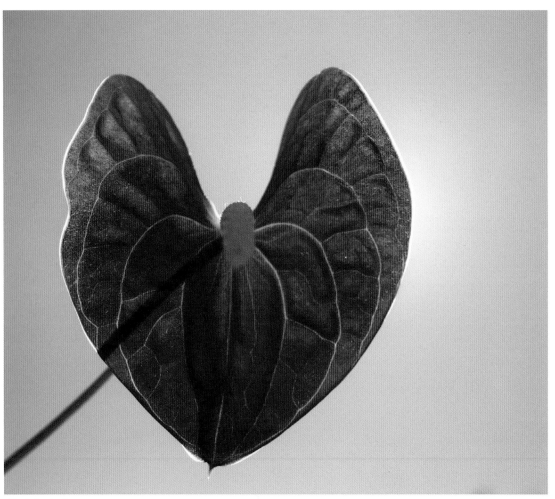

Ilaria Luciani
Love for Life or Life for Love?

Alan Bowman
A New Life Begins
This image started out as a heart that I created with acrylic paint. I photographed it digitally, downloaded it onto my computer, then began changing the colors and contours around it. As the image evolved into a picture, I tried to make it look like a birth or the creation of life.

Gabriele Helfert
Open-Hearted

Sandra Karina Serretti
Fulfillment—Dedicated to Hannes

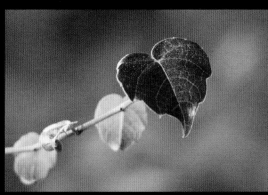

Ilaria Luciani
Love Is Everywhere If You Look Close Enough

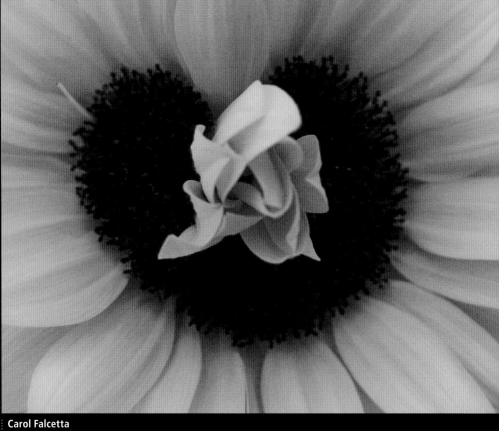

Carol Falcetta
Hearts on Fire

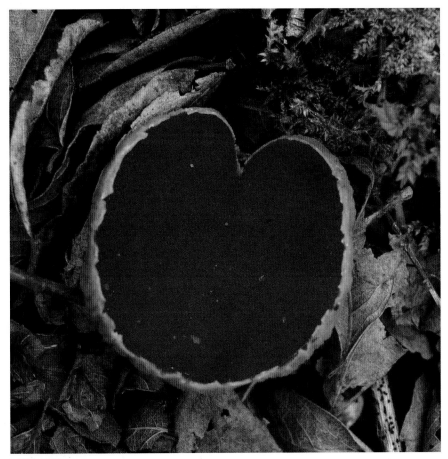

Michiel Thomas
Scarlet Heart

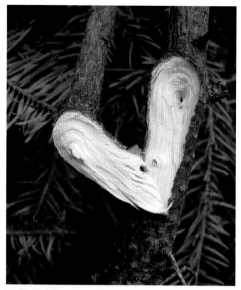

Julie Staub
Cracked-Opened Heart

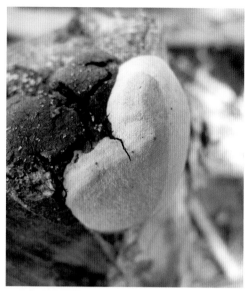

Maria F. Powell
The Heart of Nature

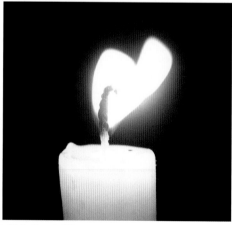

Maja Draginčić
Flaming Heart

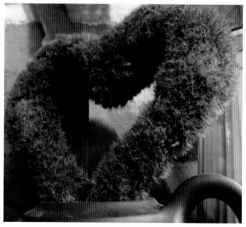

Nancy Bourdon
Love in a Restaurant

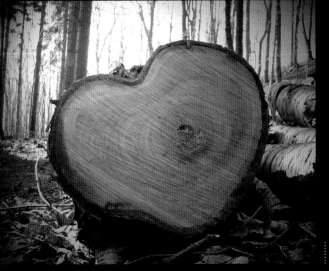

Jakob Winkler
Heart of a Tree

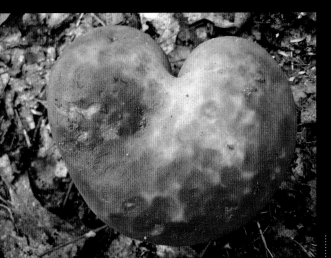

Terilyn M. Elibero
Mushroom Heart

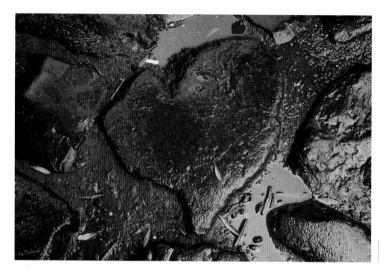

Sergio Zurinaga Fernández-Toribio
RomAAmor

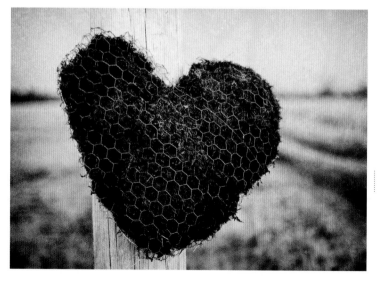

Bobby Acree
Country Valentine
This heart was made with chicken wire that was painted pink and filled with peat moss. It was attached to a telephone pole for my wife to see on Valentine's Day, which is our anniversary.

Kerstin A. Pesch
Look What I Found

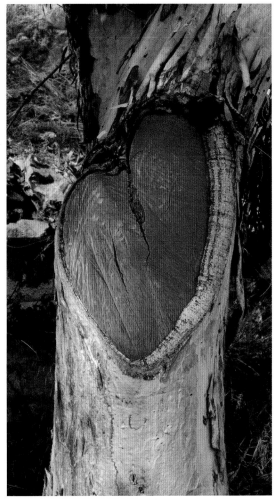

Giuseppe Allegrino
Heart

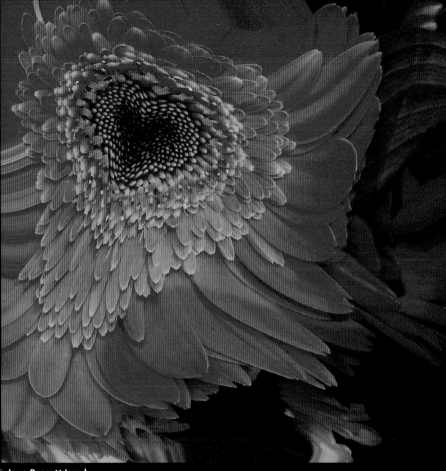

Jane Bessett Lynch
On Wings of Love

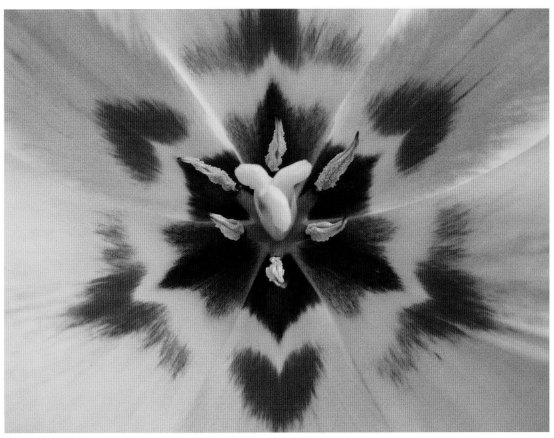

Anne Kathrine Elliott
Centre of Attraction
In an effort to bring cheer to a bitterly cold winter's day, I bought a bright potted
plant from my local grocery store. Imagine my surprise the next day when the flowers
opened, and I discovered these tiny red hearts deep within each flower.

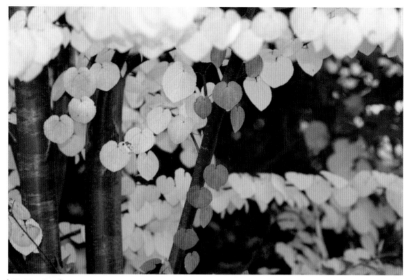

Petter Jordan
Blushing Hearts
I looked at this amazing tree each day on my way to work, and I was astounded by the colors. A tree filled with pink hearts! I just had to take the photo.

Brock Nicholson
Into the Pinks

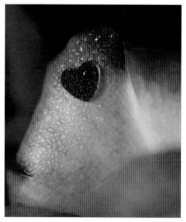

Michelle J. O'Kane
Grown Attached

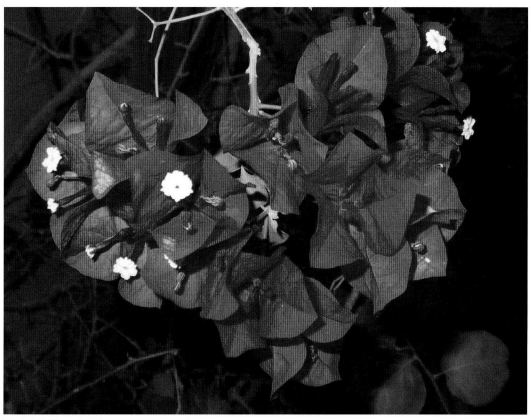

Sarah H. Biggart
Heart in Bougainvillea
One day I noticed that the bougainvillea outside my house was growing in a heart shape. It looked so beautiful and bright—it really made my day.

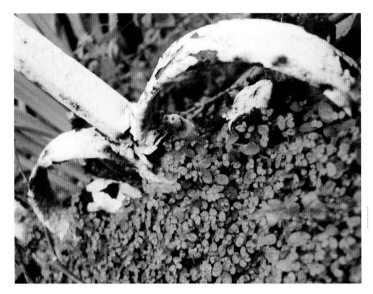

Darwin E. Bell
Through the Weeds
I love the juxtaposition in this photo of the decayed wrought iron and the fresh, thick greenery. It looks like the heart is sinking into the weeds.

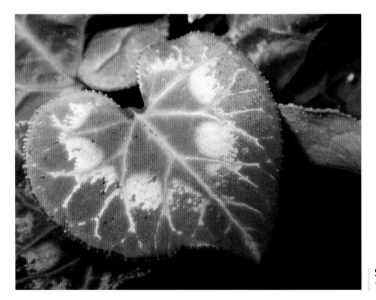

Sarah H. Biggart
Veiny Heart

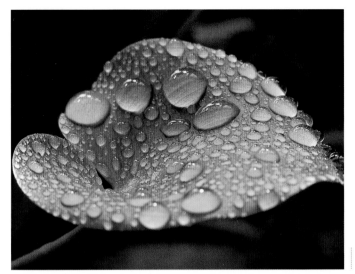

Sandra Karina Serretti
Tears of Heaven—Dedicated to Daniela

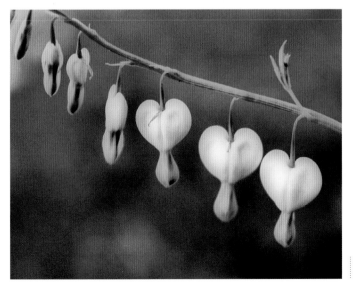

Ali Johnson
Tender Hearts

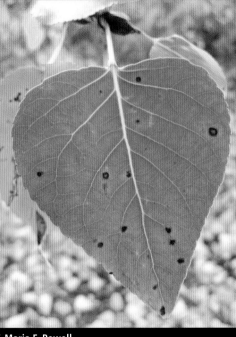

Maria F. Powell
Heart of Green

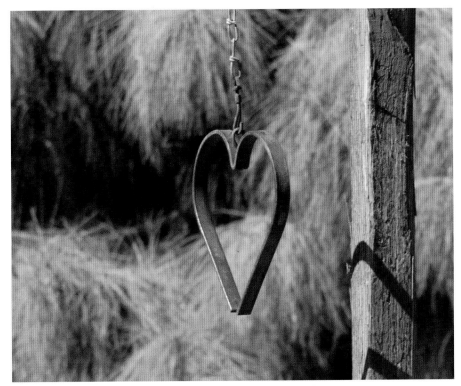

Willie Stark
Dinner Bell

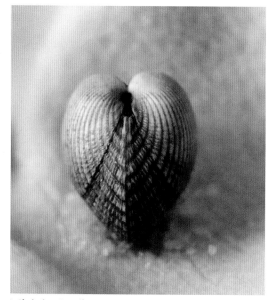

Christian Henriksen
Heart of the Sea

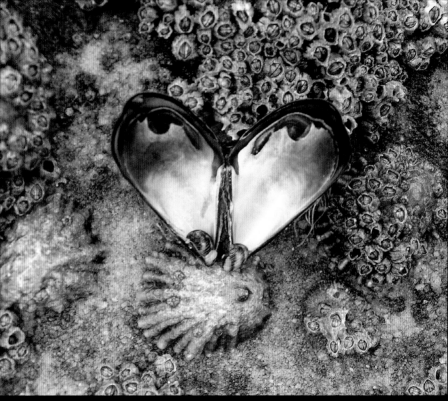

Soraia Gobin
Love in an Oyster

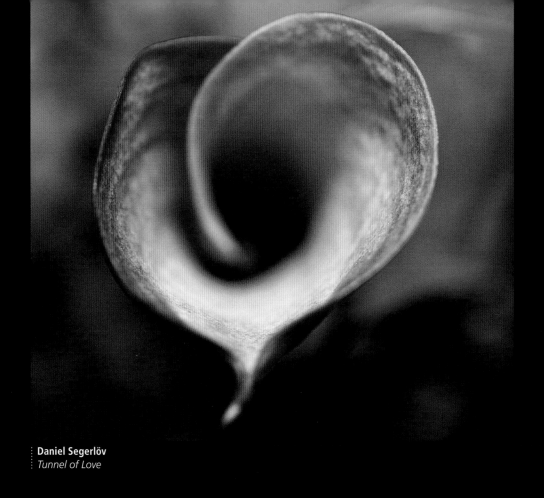

Daniel Segerlöv
Tunnel of Love

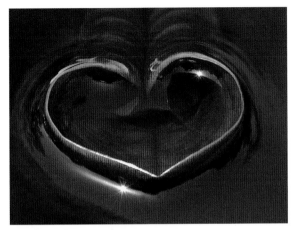

Sandra Karina Serretti
Dragon Heart—Dedicated to Nikos

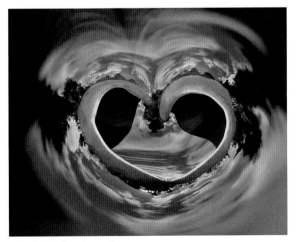

Sandra Karina Serretti
World within a World—Dedicated to Christian

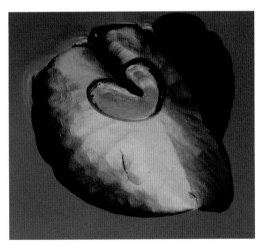

Sandra Karina Serretti
Innermost—Dedicated to Kassandra

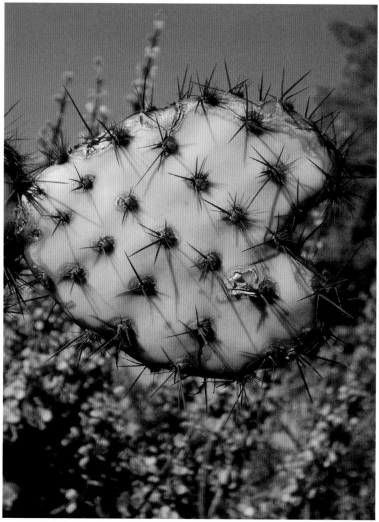

Sarah H. Biggart
Sticky Heart
 Love can get a little prickly sometimes, and this
photo expresses that perfectly.

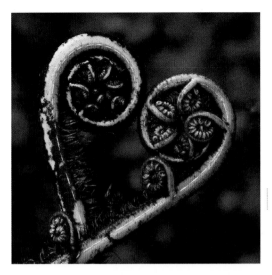

Nicole K. Henika Braun
Aroha
This heart was formed with fronds from the Ponga tree, a fern tree common to New Zealand. The shape of the unfurling frond is called the koru, which symbolizes new life, growth, and peace.

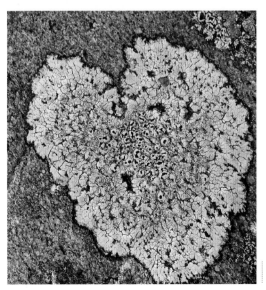

Michael Beglan
Heart-Shaped Lichen

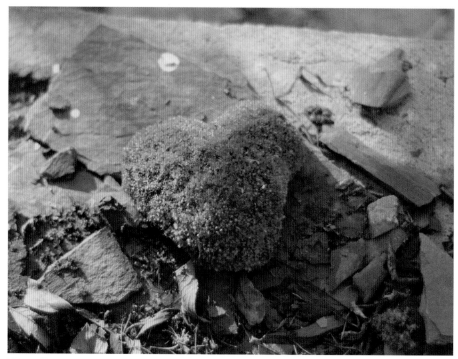

Derya Davenport
Green Heart
My boyfriend spotted this mossy heart on the doorstep, and I took
a photo of it with his camera. Our heart—green and growing—is
located in the beautiful Welsh countryside.

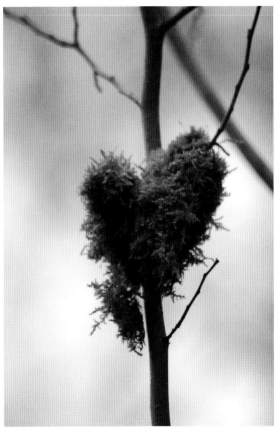

Andrew Philip Pescod
The Heart of Nature
I came upon this beautiful heart not long after Valentine's Day
one year. I found it while walking along the River Caldew in
Cumbria, in the northwest of England. The heart is made of moss.

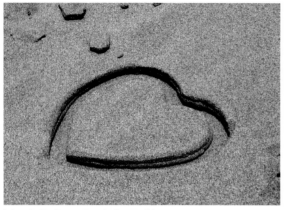

Sergio Zurinaga Fernández-Toribio
*Pintado tu Corazón en la Arena
(Drawing Your Heart in the Sand)*

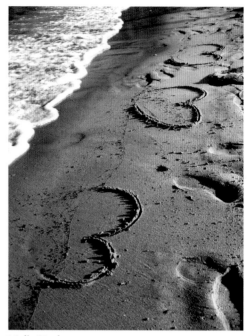

Julie Staub
Summer Love
I drew these hearts on the beach at Hoboken, New Jersey. I liked how almost as quickly as I drew them, the tide washed them away—just like a summer fling.

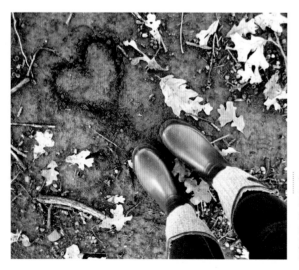

Jennifer Stuart
Lost and Found
I photographed this heart sketched in the dirt as a representation of love found in unexpected places. It's also a partial self-portrait, showing only my feet, that implies a personal journey. For me, the image stands for the love and happiness I've reached at this moment in my life.

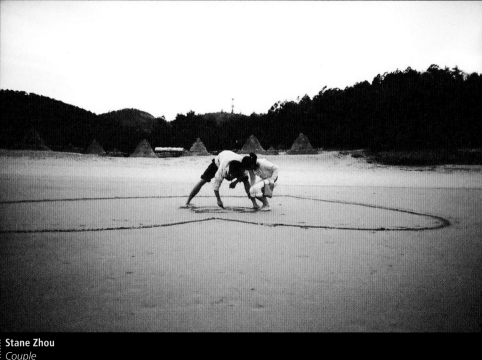

Stane Zhou
Couple

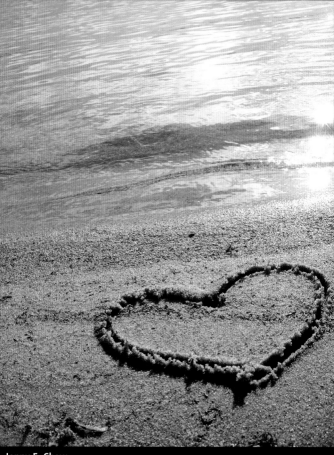

Jenny E. Chew
Love on the Beach

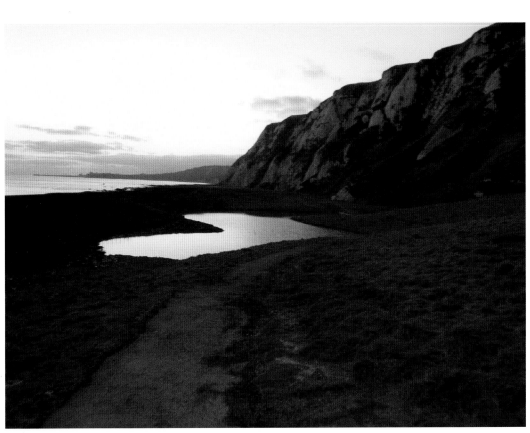

Karla Griffiths
Heart-Shaped Lake at Samphire Hoe
I photographed this lake at Samphire Hoe, a nature spot located
at the base of the White Cliffs of Dover in Kent, England.

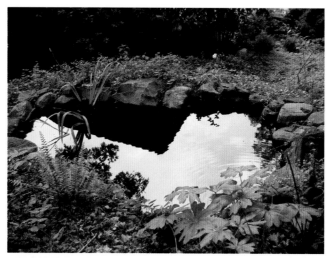

Marjorie Frost Fitterer
Heart-Shaped Pond Created by a Reflection

Gizem Inan Erman
A Heart That Belongs to No One

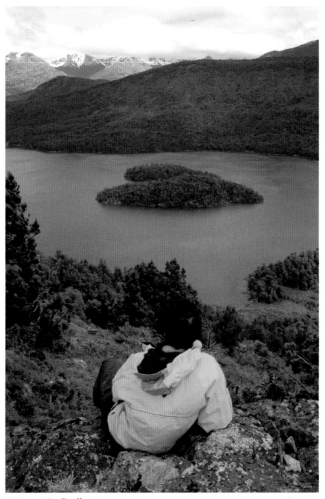

Marcos Radicella
El Padima y la Isla Corazón
My brother is in this photo. The heart-shaped island he's admiring is located in Mascardi Lake in Patagonia, Argentina.

Saharsh D'Cruz Cherian
Secret Heart

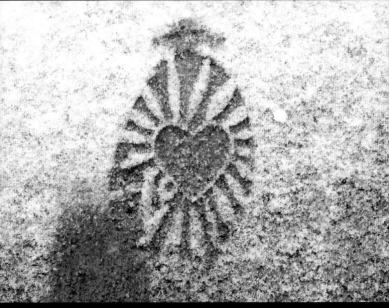

Brandy L. Woods
Snowprint

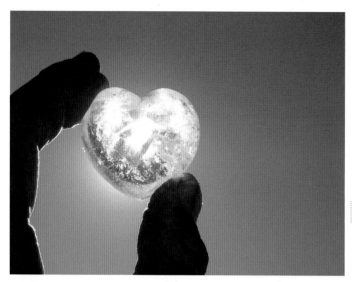

Horst Bernhart
Let the Sunshine In
I bought this crystal heart in a small store in Montana. It was cold in appearance, so I decided to hold it up to the sun, and instantly it glowed with beauty and radiance.

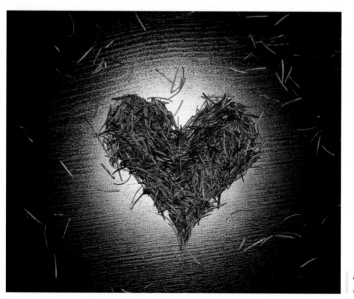

Amelia Read
Pine Needle Heart

Peggy Reimchen
Heart-Shaped Cloud in a Lake

Julie Staub
Love Is in the Air

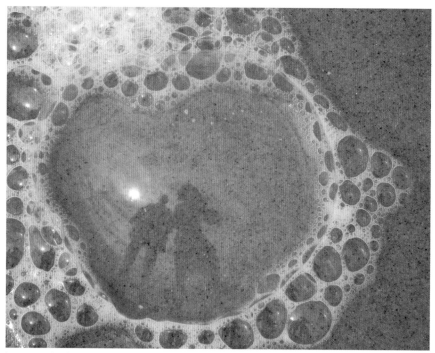

Peggy Reimchen
Caught in a Heart
As the waves crashed onto the beach of Barra do Saí in Paraná, Brazil, I noticed that my husband and I were reflected in each and every one of the bubbles. Trying to capture our reflections prior to the popping of the bubbles was great fun.

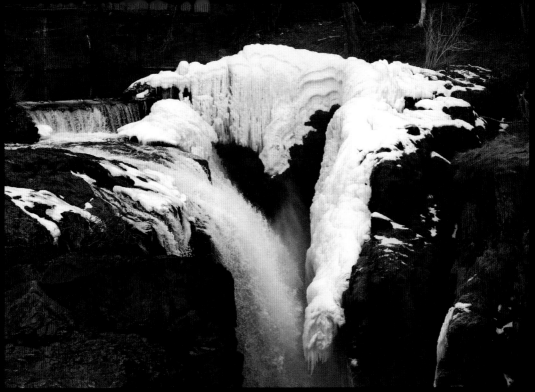

Alice Grebanier
The Heart of the Falls
I think that the Great Falls in Paterson, New Jersey, are always breathtaking to see. But
I actually gasped when I saw this heart shape in the falls one frigid February morning.

Helena Felix Peixoto
Coração

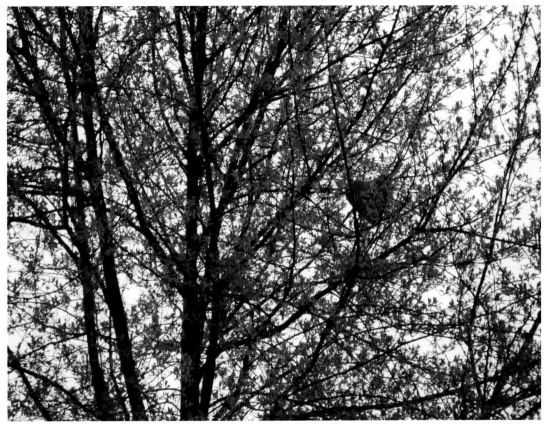

Christiane Hering
Clara-Zetkin

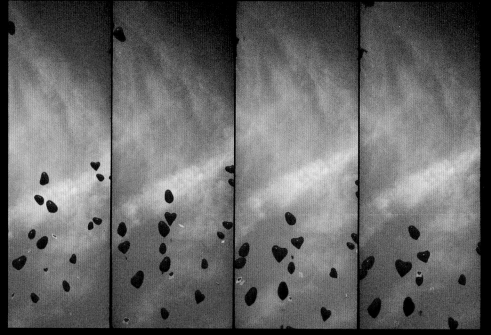

Stefan Georgi
Flying Hearts

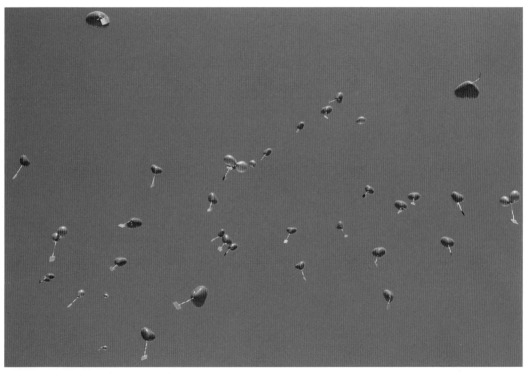

Martin Q

Hearts in the Sky

This photo was taken at a wedding in Germany. Attached to each balloon was a voucher filled in by a wedding guest. Any cards that were found and returned to the newlyweds could be traded in for the promise written on the voucher. My card was found, so I cooked an English breakfast for my friends in their new home.

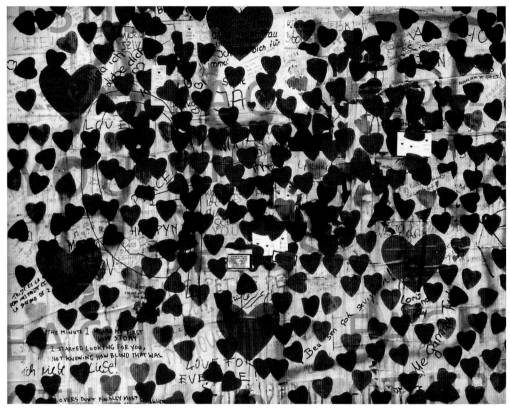

Carsten Friedrich
Otto von Bismarck Said: "Die Majorität hat viele Herzen, aber ein Herz hat sie nicht."
("The majority has a lot of heart, but a heart it has not.")
These hearts are pasted on an information board in the city park of Berlin-Kreuzberg in Berlin, Germany. Passersby have scribbled love-related notes on the board.

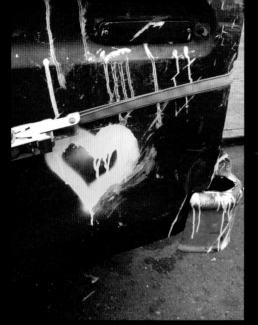

Patricia Spencer
The Red Heart Truck
I walk past this heart almost daily. It's painted on the side of a battered old pickup truck that serves as a repository for trash bags bound for the dump. Who put it on there and why, I don't know.

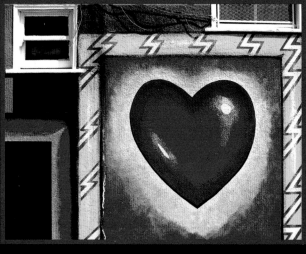

Michael Anderson-Andrade
El Corazón de mi Barrio (The Heart of My Neighborhood)

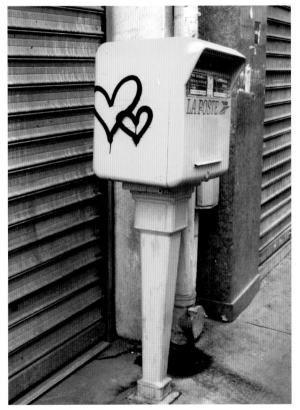

Gabrielle Allemand
Mailbox Love

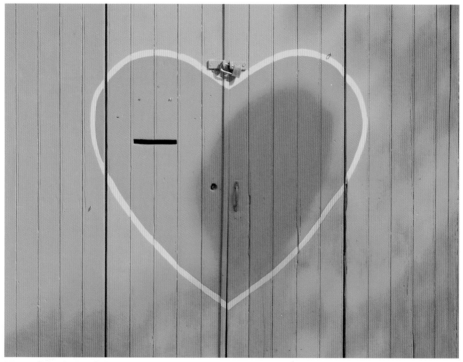

Raquel Garcia Cataluña
De Todo Corazón

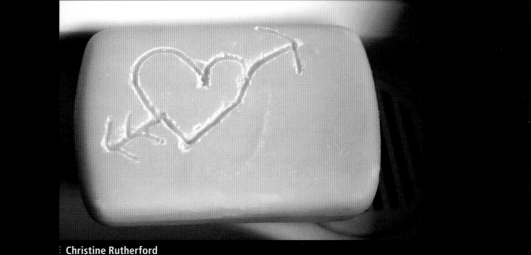

Christine Rutherford

Lester E. Weiss
Melrose Avenue Heart, Los Angeles

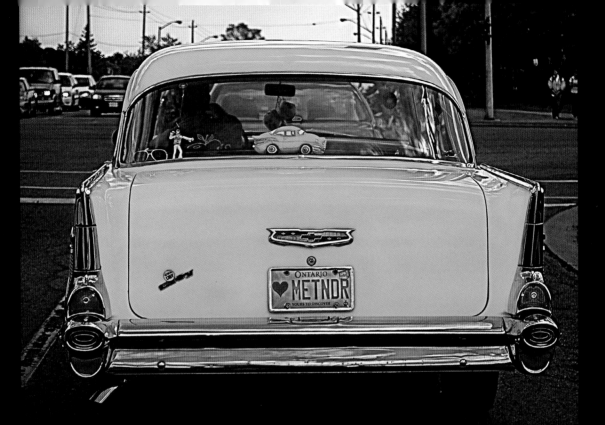

Tom Linardos
Retro Ride

Nancy Scott Dougherty
Invasion of the Heart Snatchers

Marjorie Frost Fitterer
Wearable Heart Art

Wickham Irwin
Love on the Go

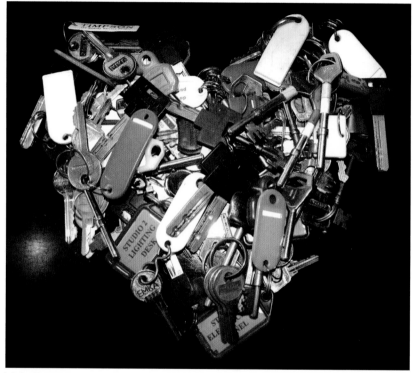

John Brewster
Key to My Heart

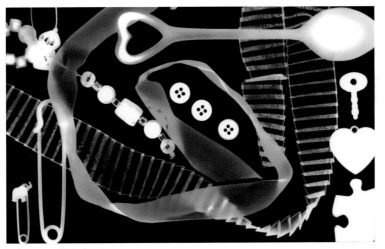

Shaunee Christine Bretz
Heartogram

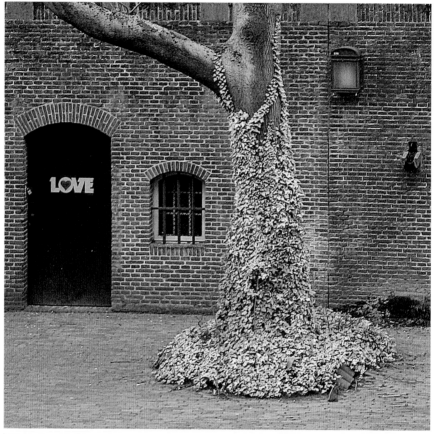

Vincent van Galen
Knock Knock

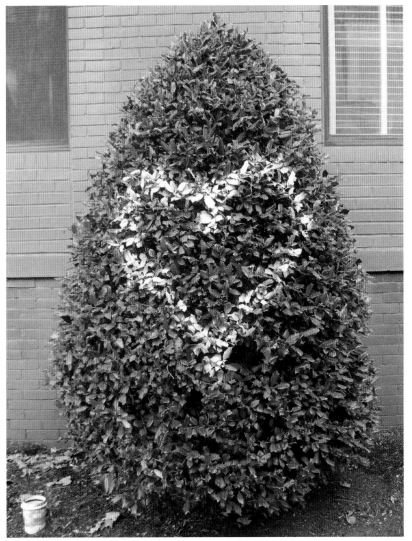

Soraia Gobin
Heart on a Holly Bush

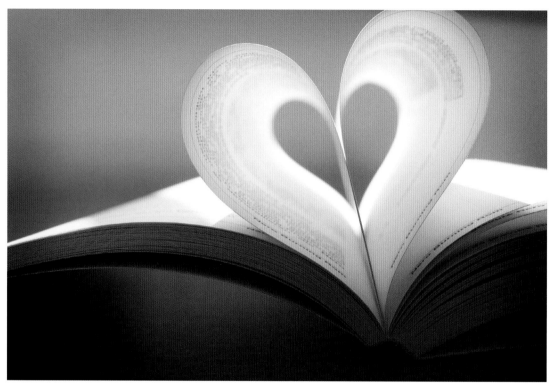

Ilaria Luciani
Thanks for Staying So Close

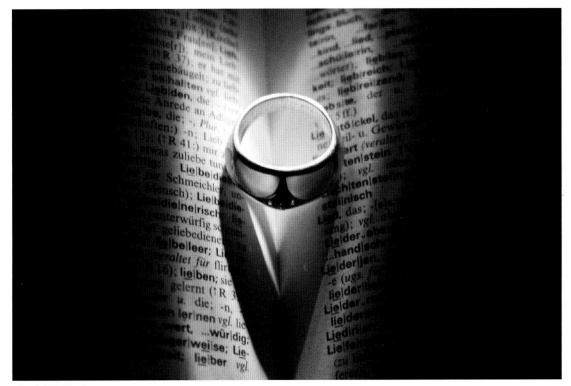

Daniel Wolfrath
Liefde

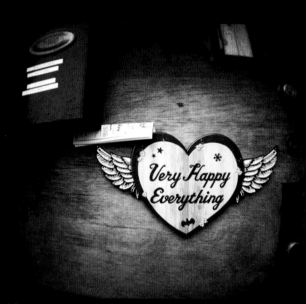

Erica Barraca
Very Happy Everything

Ali Johnson
To Fool the Queen

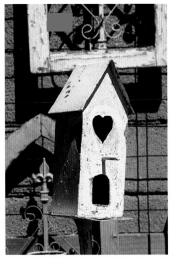

Willie Stark
Love Perch

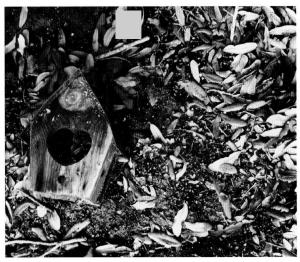

Courtney N. Boydston
Heart's Haven

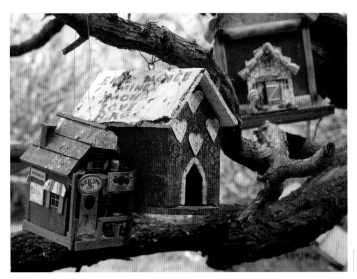

Willie Stark
Home Is Where the Heart Is

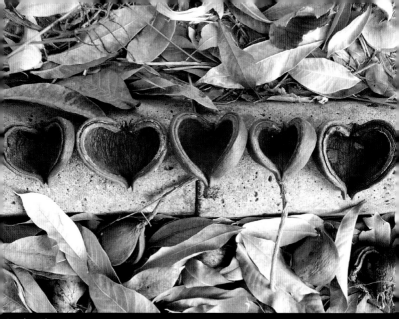

Jessica Rigney
Skunk Tree Pod Hearts

I shot this photo during a visit to Honolulu's Foster Botanical Gardens, a place known for unusual trees and plants. I could smell the skunk tree before I found it. I looked up and saw pods on the tree, looked down and found them all over the ground. Some had already dried up and split open, leaving a heart shape. I gathered a few and lined them up on the closest thing I could find—a piece of concrete edging—and took this picture.

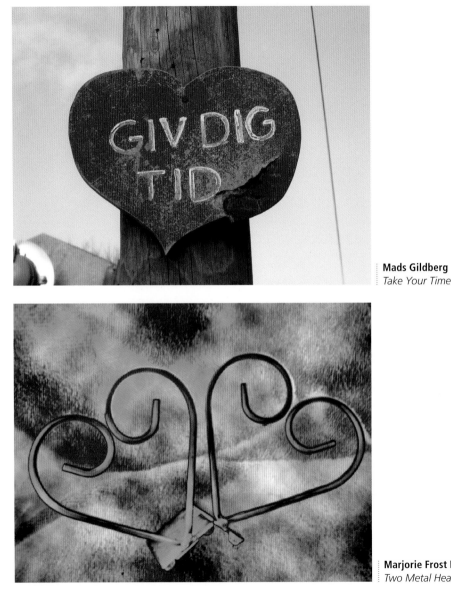

Mads Gildberg
Take Your Time

Marjorie Frost Fitterer
Two Metal Hearts

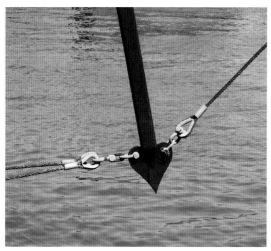

Françoise Lecomte
Dolphin-Striker, Oostende, Belgium

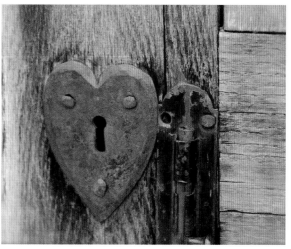

Elaine Warren Heburn
Key to My Heart
I took this picture during a visit with my family to Fort Ticonderoga in upstate New York. This is an image of a rusty lock set that was on one of the doors leading to the upper level of the fort. When I saw it, I wondered why the locksmith took so much time with the lock set, and why he chose to make it in the shape of a heart. I loved the fact that, so many years ago, the heart symbol meant something to him. Something caused him to do that extra bit of work—even in a culture where there was no time for rest.

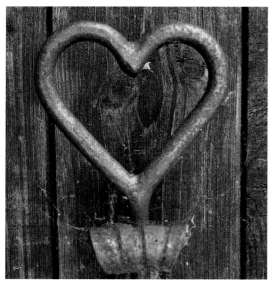

Anja Rehatschek
Heart at the Door

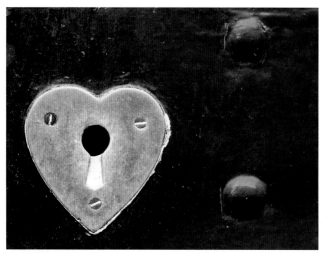

Michelle J. O'Kane
Who Has the Key?

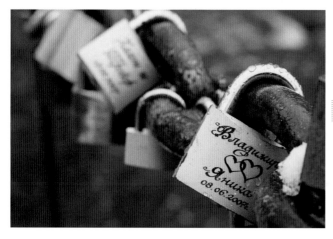

Kathy Jürivete
Padlock in Keila-Joa
I took this picture in Keila-Joa, Estonia. While there, I came across a bridge that had hundreds and hundreds of padlocks attached to it. I found out that it's a tradition for couples who visit Keila-Joa to leave behind a padlock inscribed with their names and the date they met or got married. The engraving on the padlock in the photo represents the love between a Russian boy and an Estonian girl.

Valentina Merzi
Well-Locked Heart in Venice

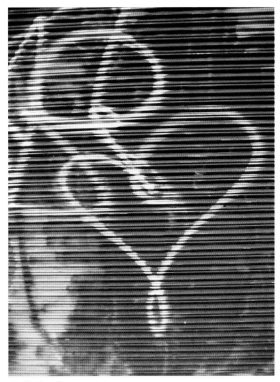

Julie Staub
Heart of Steel

Gabriele Helfert
The Lady and the Blue Heart

Marilyn J. Martin
The Textured Heart

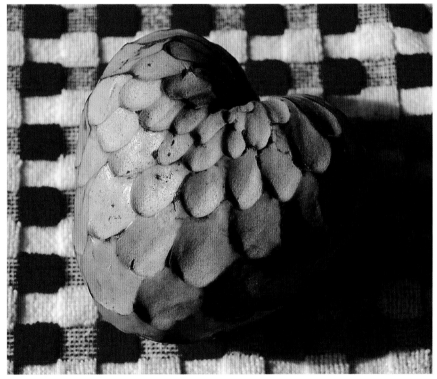

Jacquelynn Vance-Kuss
Cherimoya
This cherimoya was an impulse buy. I was drawn to it by its
cheerful shape and wonderful texture.

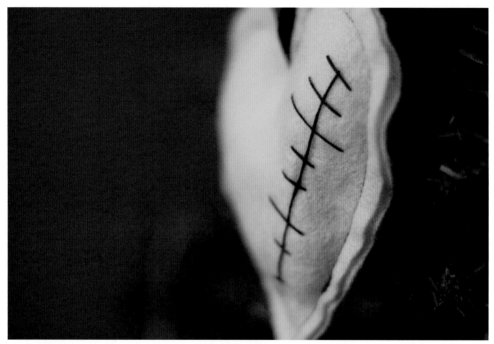

Kelly Teague
A Heart Sewn Back Together
This is a Christmas ornament that I received from my girlfriend. It's a perfect symbol of how the heart can withstand so much—survive difficult times—and still come out okay.

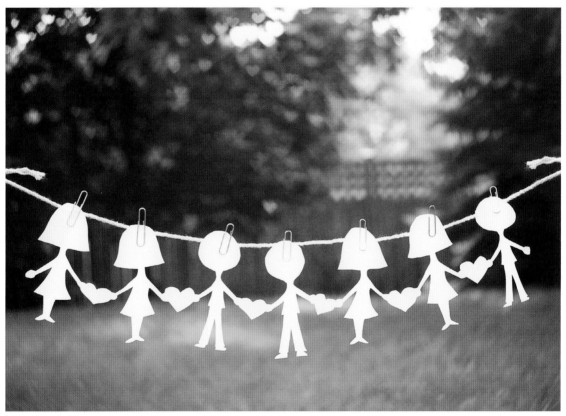

Erica Marshall
We Are All Connected

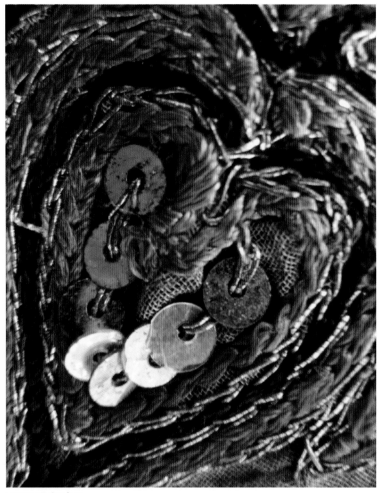

Peggy Reimchen
Embroidered Sequined Hearts
I purchased this heart-shaped cushion cover in a local market
in Jaipur during an incredible month-long tour of India.

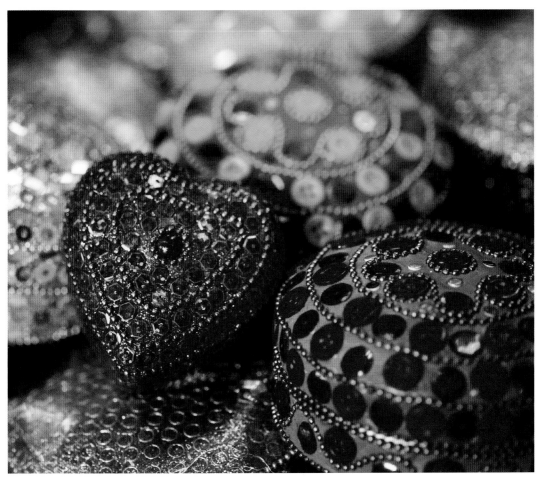

Lawrence Wee
Colors of Little India
This heart-shaped trinket is a small jewelry box that was made by
hand. I found it in an ethnic district in Singapore called Little India.

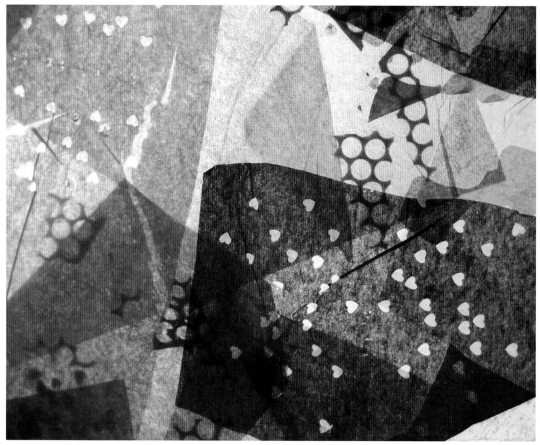

Julie Staub
Heart Art
I'm always finding the heart symbol in nature or formed by ordinary, everyday objects. When I come across it, I'm inspired to capture it with my camera. It reminds me that love is all around us all the time.

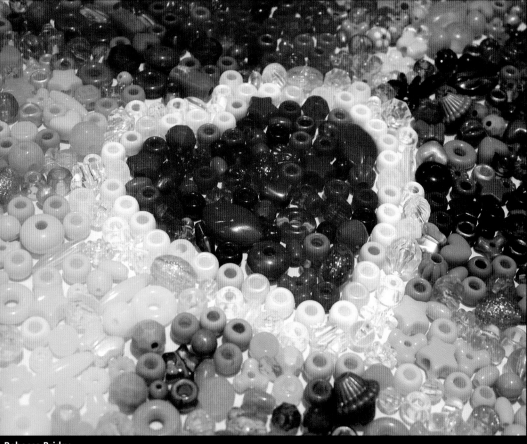

Rebecca Bridge
Bead Heart

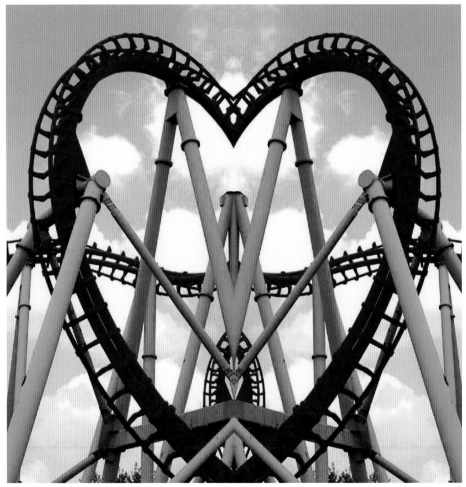

Thomas Rebler
Love Is…

Sergio Zurinaga Fernández-Toribio
Corazón Errante (Wandering Heart)

Fatma Seyma Birkandan
My Heart Is Burning

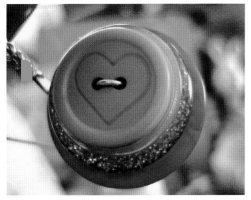

Jessica Starr Mundt
Button Love

Susan Scribner
Hearts and Flowers

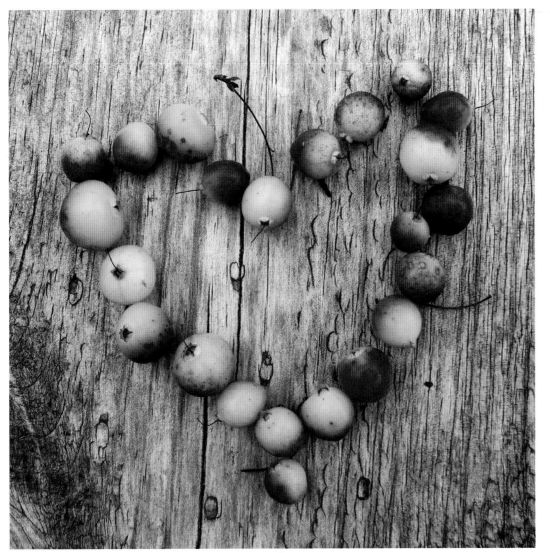

Kristi Roovik
Bittersweet

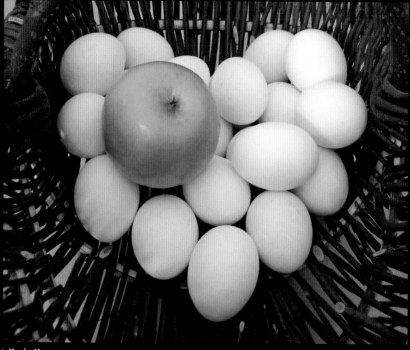

Karin Herzog
Osterherz

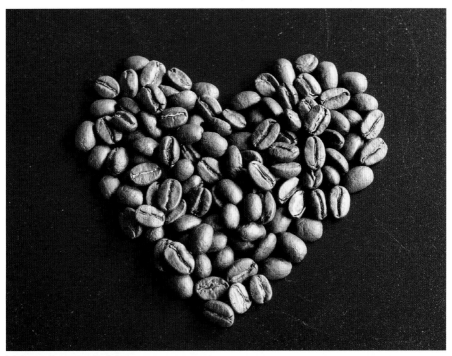

J. Jorge Contreras Rodríguez
I Love Coffee, Especially on Monday Morning

Tuli Nishimura
Heart of Peanut

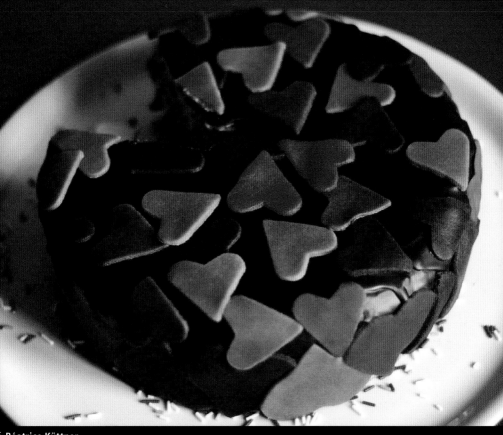

Béatrice Küttner
Cake

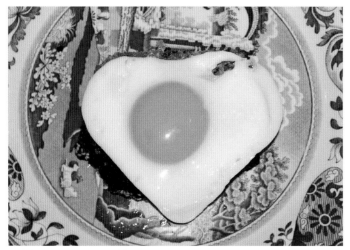

Edilson Rodrigues da Silva
Egg Heart

Maritza Piña Bustamante
Cornyheart

Marta Colpani
A Hidden Heart

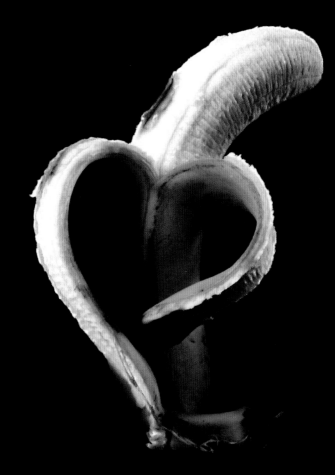

Francesca Birini
The Fruit of the Original Sin

Jessica Starr Mundt
Hey, Lover Boy...
My husband and I were baking cupcakes for Valentine's Day when I found the perfect conversation heart for the top of his cupcake. He loved it!

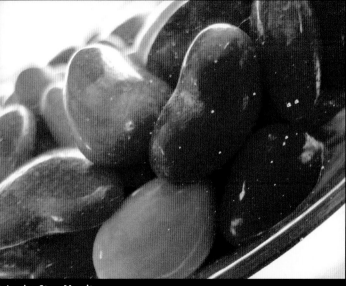

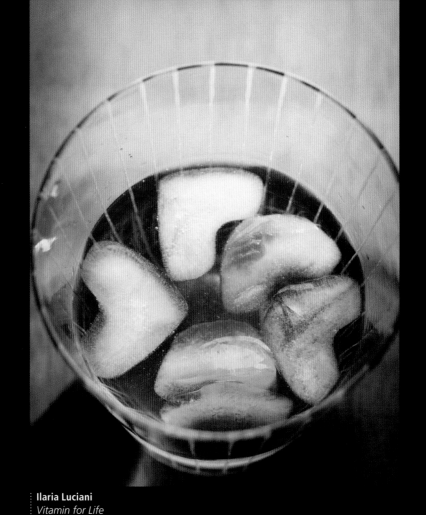

Ilaria Luciani
Vitamin for Life

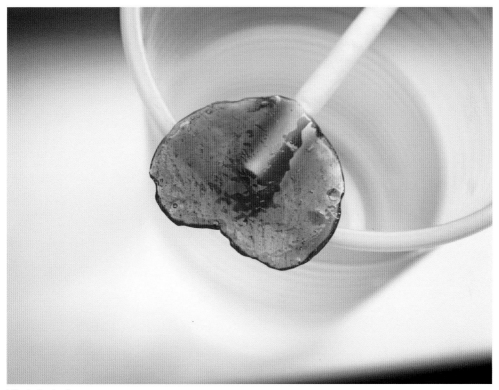

Ilaria Luciani
Heart Me

Sarah Azavezza
Soften Your Heart
We live in a world where people resent each other. As time goes by, it seems like resentments grow, and people's hearts become stone, getting hard and closing up to everything that approaches. So I thought of a sweet way to undo all that hardness.

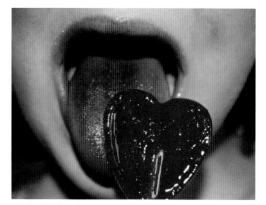

Elisa Santarelli
Piccole Gioie

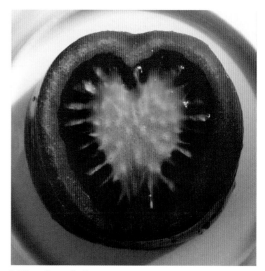

Alissa Rosenhaft
Heart-Shaped Tomato

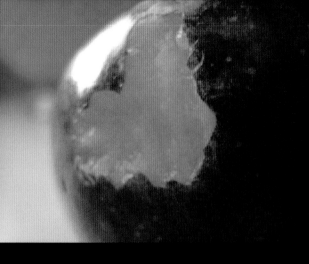

Jessica Starr Mundt
Dawson's Heart
My son took two bites out of an apple and—purely by chance—produced this lovely heart. He was so excited that we had to have a photo shoot!

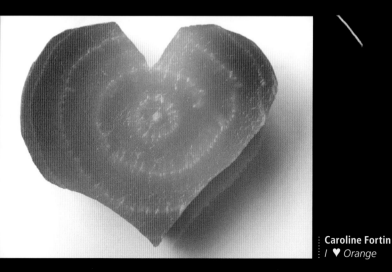

Caroline Fortin
I ♥ Orange

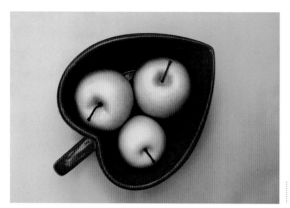

Sofia K. Smith
Apples

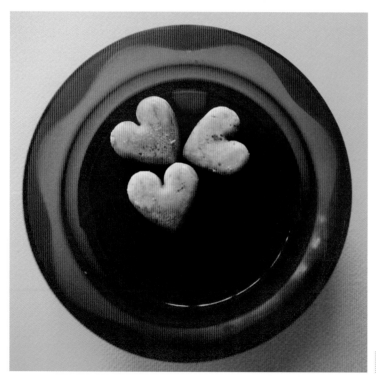

Christine Rutherford
Mother Love (4 Veg in 3 Hearts)

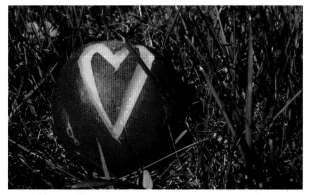

Joséphine Annika Moser
Nectarine

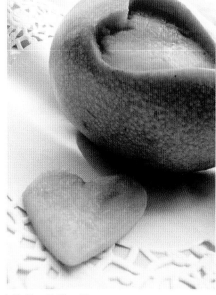

Mylène Taillon-Viger
Daydreams of Sweetness

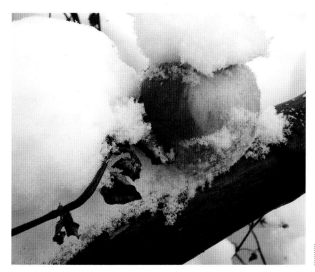

Karin Herzog
Apfelherz im Schnee

Horst Bernhart
Potato Heart
While helping to prepare dinner at a friend's house, I came
across this heart-shaped potato. The shape compelled me to
document the potato before it was eaten and forever lost.

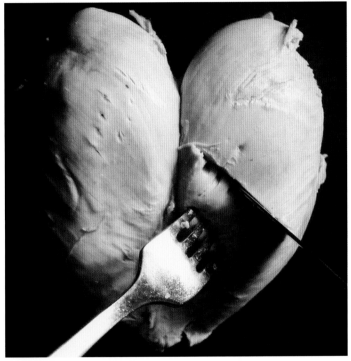

David Yerga Acedo
Corazón Trinchado
This heart is made of a chicken's breast. When I took the picture, the chicken was being cooked in a frying pan. My wife noticed its curious shape, and we made a series of photos from it.

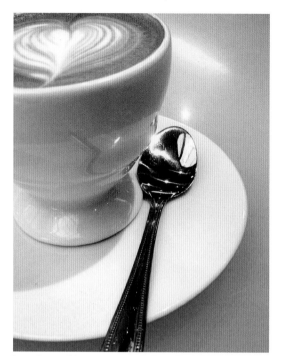

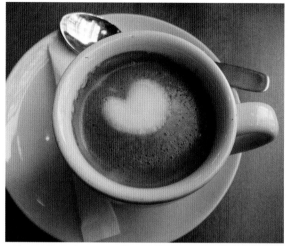

Simona Rasetti
My Heart Coffee

Katrina Jenkins
Latte Love
I wanted to believe that the barista was sending
me a special message by putting a heart in my
latte, but everyone else received one, too.
I love the symmetry of a heart. I also like the
fact that it has rounded edges as well as a point.

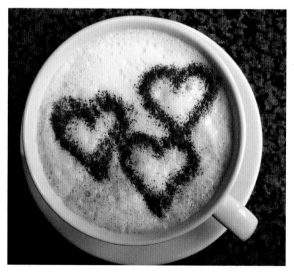

Shawn Ryan Scharlemann
The Three Hearts
This picture was taken during a trip my husband and I made
to Leipzig, Germany. It was quite cold outside, so we dropped
into a cafe and ordered cappuccinos. The woman serving
us picked up a silver canister, tapped it a couple times, and
voila! Three cinnamon hearts adorned the top of my coffee!

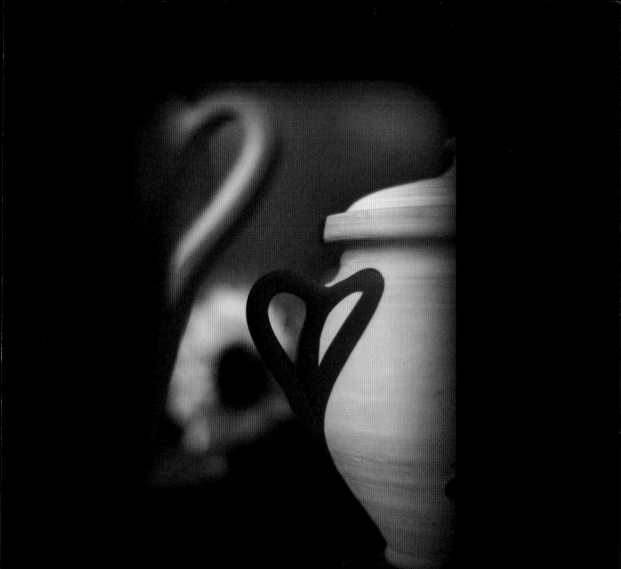

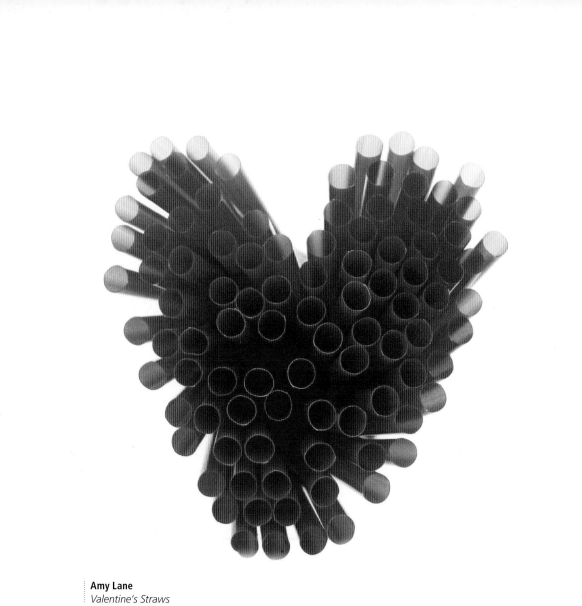

Amy Lane
Valentine's Straws

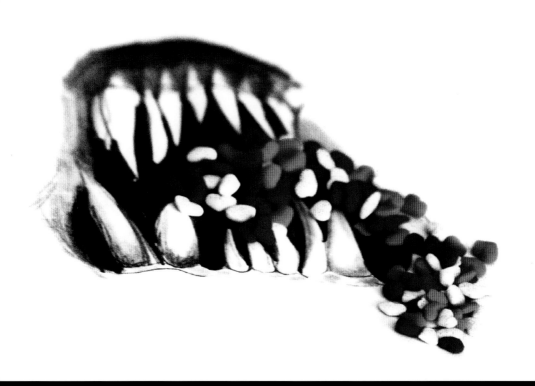

Ellen M. Yeast
Sprinkle Monster

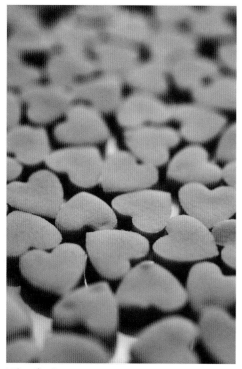

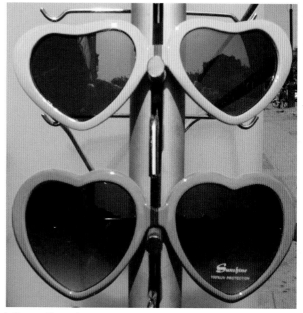

Simona Rasetti
Sunglasses Pink Hearts! (From London, with Love)

Timothy Green
A Hearty Plate
These pink icing hearts were created with a heart-shaped cutter by my 10-year-old daughter. I took this colorful shot before the hearts were used to decorate her birthday fairy cakes.

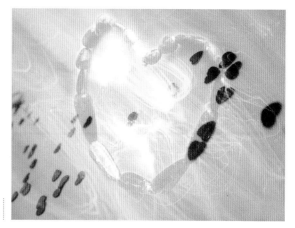

Rebecca Bridge
Hearts

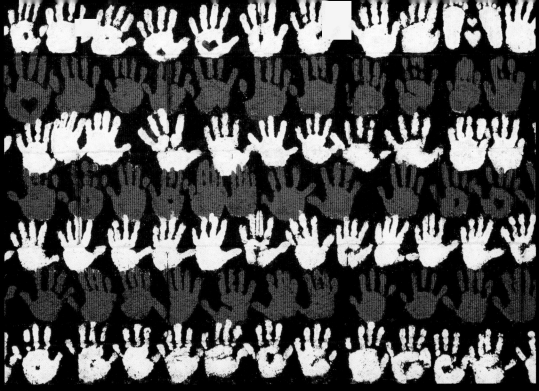

Willie Stark
Hands & Hearts

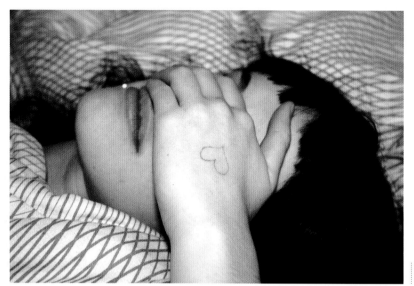

Florian Reimann
Herzdame

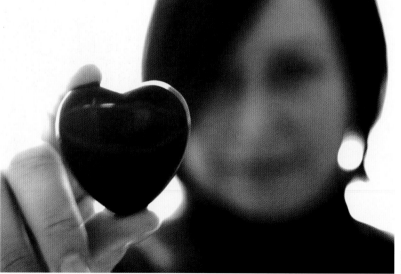

Marta Colpani
A Hidden Heart

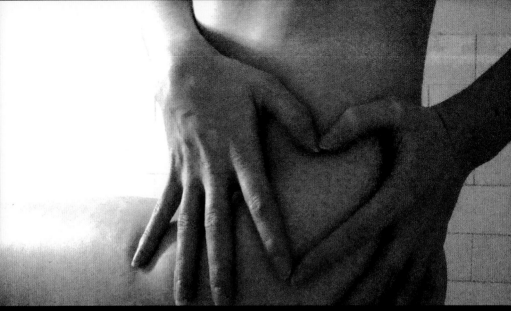

Julie Court
Today I Am…Accepting My Body

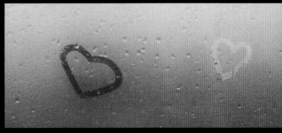

Mariusz Chrzanowski
Lonely Hearts

Russier Laurence
Coeur de Sucre

Debra Mineely
Buttoned Hearts

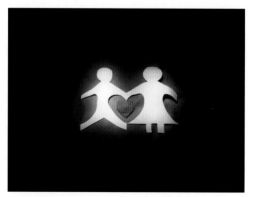

Raditya Fadilla
Gradually Swollen

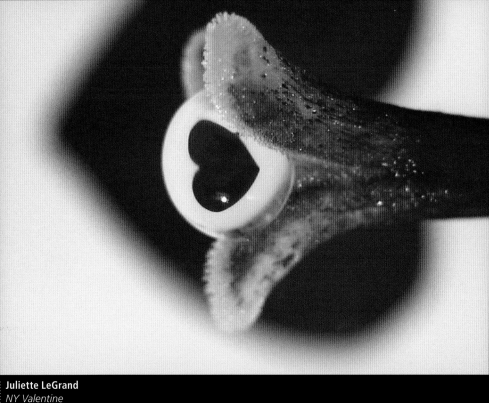

Juliette LeGrand
NY Valentine

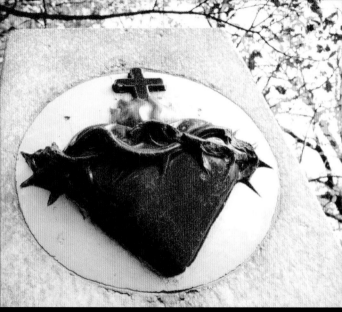

Rachel N. Titiriga
Sacred

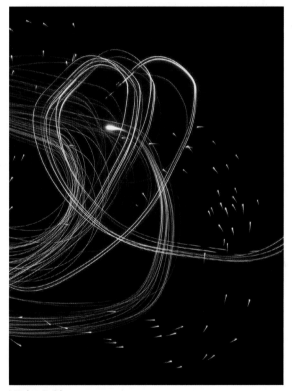

Helen Reid
Heart Strings

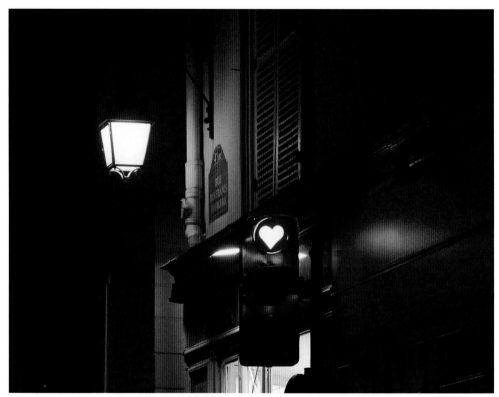

Rui Pereira
Stop in the Name of Love

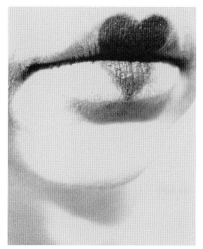

Helen Reid
Geisha Girl

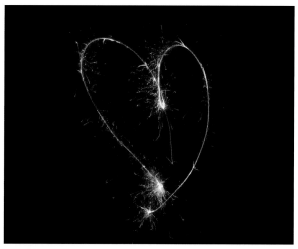

Béatrice Küttner
Sparkle

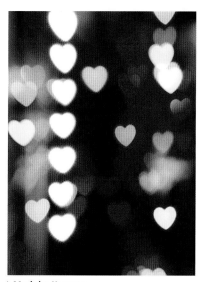

Madoka Komano
Baby Hearts

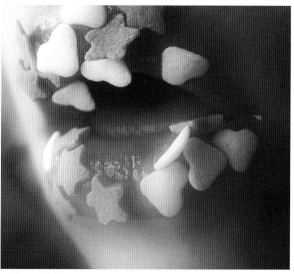

Rebecca Bridge
Star Heart Lips

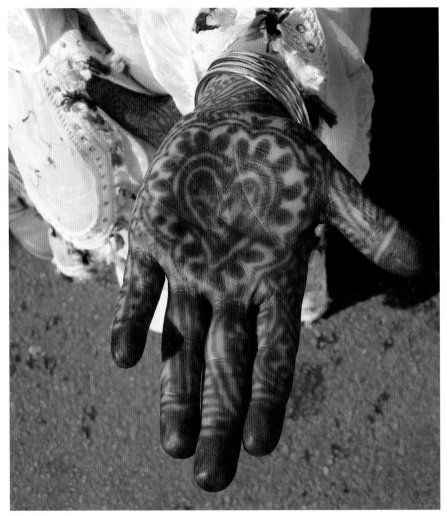

Jacqi Bartlett

Henna Heart

This beautiful little girl was standing with her mother near the market in Fes, Morocco.
Her hand was decorated as part of a festival that's held every year in Fes.

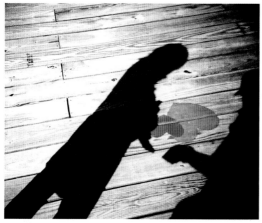

Molko Chan
Heart on Our Hands

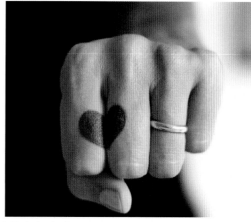

Ilaria Luciani
All I Need Is Love

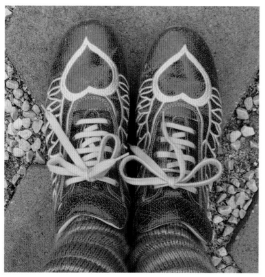

Kat Coyle
Hearts

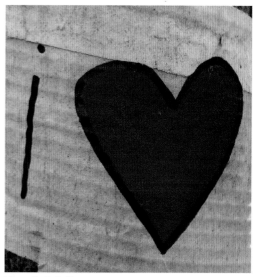

Darwin E. Bell
I Heart…

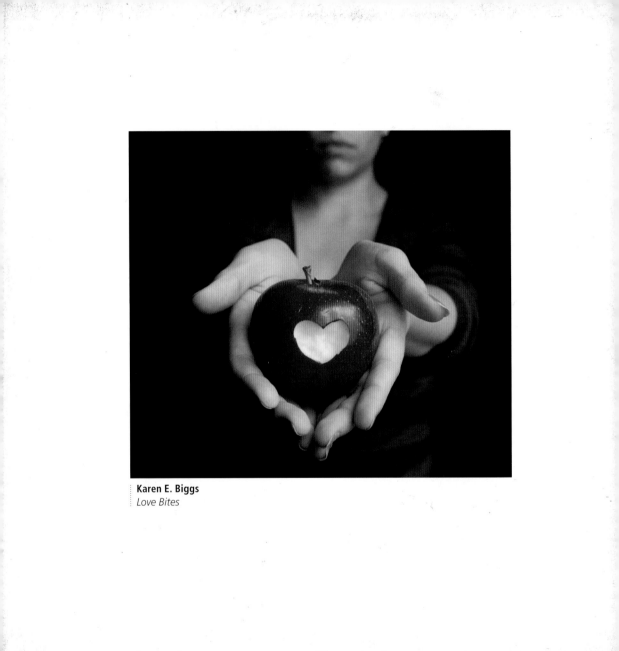

Karen E. Biggs
Love Bites

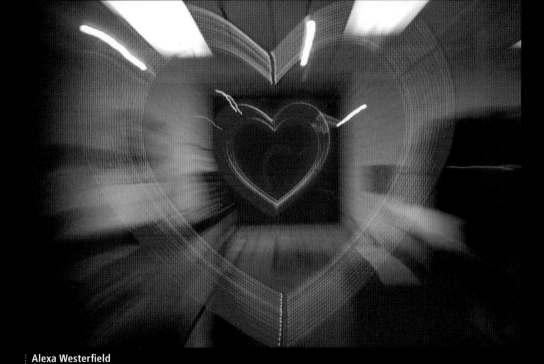

Alexa Westerfield
Heart Attack

Index of Contributing Artists

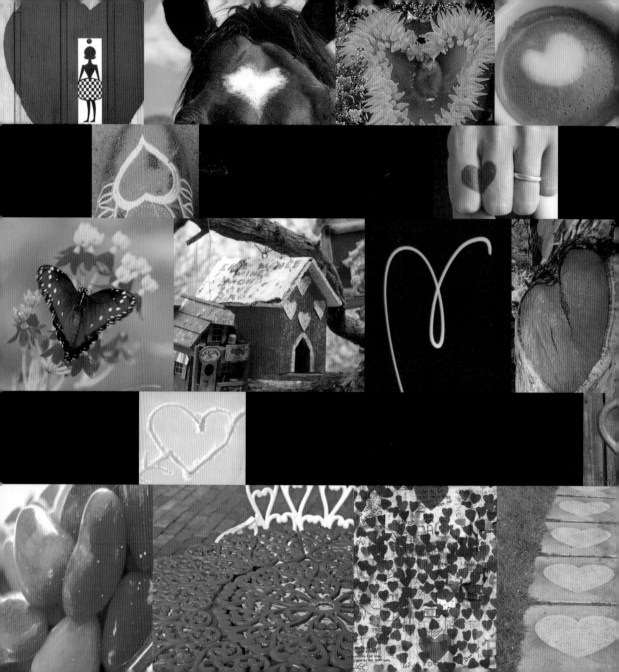